GEORGIA O'KEEFFE & ALFRED STIEGLITZ

TWO LIVES

"Two Lives," a man's and a woman's, distinct yet invisibly joined together by mutual attraction, grow out of the earth like two graceful saplings, side by side, straight and slender, though their fluid lines undulate in unconscious rhythmic sympathy, as they act and react upon one another: "There is another self I long to meet Without which life, my life is incomplete." But as the man's line broadens or thickens, with worldly growth, the woman's becomes finer as it aspires spiritually upward, until it faints and falls off sharply — not to break, however but to recover firmness and resume its growth, straight heavenward as before, farther apart from the "other self," and though never wholly sundered, yet never actually joined.

Henry Tyrrell, 1917

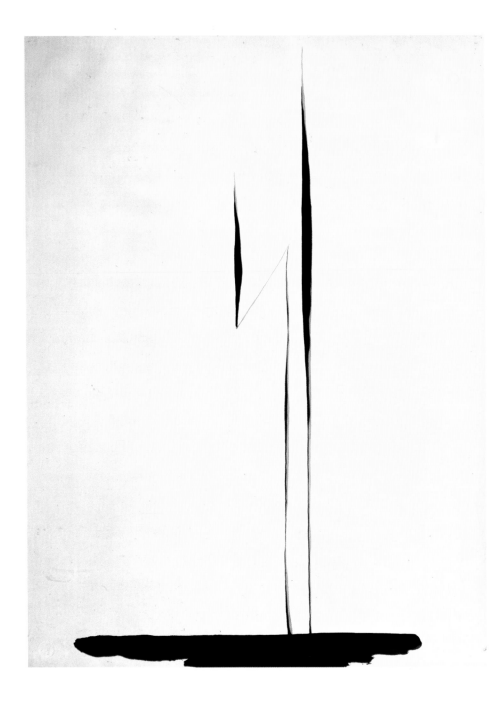

GEORGIA O'KEEFFE & ALFRED STIEGLITZ

TWO LIVES

A CONVERSATION IN PAINTINGS AND PHOTOGRAPHS

Essays by Belinda Rathbone, Roger Shattuck, and Elizabeth Hutton Turner

Edited by Alexandra Arrowsmith and Thomas West

HarperCollins*Publishers* / Callaway Editions

In association with The Phillips Collection, Washington, D.C.

New York 1992

Front jacket photograph: *Georgia O'Keeffe: A Portrait — Prospect Mountain, Lake George,* 1927.
Gelatin silver print, 4 5/8 x 3 11/16 in (11.7 x 9.4 cm). National Gallery of Art, Washington,
Alfred Stieglitz Collection (1980.70.223). Photograph by Philip A. Charles.

Front jacket painting: *Iris* [*Dark Iris No.1*], 1927.
Oil on canvas, 32 x 12 in (81.3 x 30.5 cm). Taylor Museum for Southwestern Studies
of the Colorado Springs Fine Arts Center. Photograph by Steven Sloman.

Frontispiece: *Blue Lines X,* 1916.
Watercolor on paper, 25 x 19 in (63.5 x 48.3 cm). The Metropolitan Museum of Art,
Alfred Stieglitz Collection, 1969 (69.278.3). Photograph by Malcolm Varon.

Exhibition Itinerary

The Phillips Collection, Washington, D.C., 12 December 1992 – 4 April 1993

IBM Gallery of Science and Arts, New York, 27 April – 26 June

The Minneapolis Institute of Arts, Minneapolis, Minnesota, 17 July – 12 September

The Museum of Fine Arts, Houston, Texas, 2 October – 5 December

First Edition

Library of Congress Catalog Card Number: 92-52595

ISBN 0-06-016895-1

Manufactured in the United States of America

CONTENTS

EDITORS' INTRODUCTION

Georgia O'Keeffe and Alfred Stieglitz were, by any measure, two of the most significant artists to have worked in America during the twentieth century. In their own ways, both exerted a powerful influence on the visual imagination. Alfred Stieglitz brought photography into the twentieth century, made it into a respected art form, and then went further. Prompted by O'Keeffe's own semi-abstract work, he investigated the proximate and at times interchangeable qualities of representation and abstraction, making images of the sky and clouds. O'Keeffe developed a lyrical abstract style that had toughness and energy — as well as a formidable chromatic range.

By the time Stieglitz met O'Keeffe he had already almost single-handedly introduced advanced European art to the American public. Once the success of that same art had been consecrated at the famous Armory show in 1913, Stieglitz, always a contrarian, turned away from the Europeans and concentrated on promoting an *American* avant-garde. For this reason O'Keeffe was a god-send, as he readily admitted. She had created, seemingly in isolation, an original style that had a wallop. Remarkably, there was little in her early drawings and watercolors to remind one of Italian Divisionism, French Cubism, or German Expressionism. The same could not be said for most other advanced artists at Stieglitz's gallery, 291, including great ones like Marsden Hartley, John Marin, and Arthur Dove. O'Keeffe was the ideal protagonist for Stieglitz's American crusade. Together, the two of them propagated and embodied an attitude towards creativity and independence whose influence was greater even than the power of two important bodies of work.

But O'Keeffe and Stieglitz were also lovers, were husband and wife, and shared an intimate and creative life that is much more difficult to describe or assess. This is what this volume attempts to address. We present here the purely visual, artistic evidence of two lives spent together along with three distinguished scholars' thoughts and speculations about this relationship.

The plate section is divided into three parts, each of which begins with a new phase in the artists' relationship. The first years, 1916 to 1920, were a time of discovery and of the exaltation when both the photographer and the painter set out to make a new kind of art. The year 1918, when Stieglitz and O'Keeffe at last fell in love, is marked by three photographs on pages 32 and 33 in which Stieglitz has transformed the emblems of O'Keeffe's creativity, her hands, into elegant, almost exquisite forms. His love, his infatuation, perhaps even a touch of possessiveness, can be felt in these images. The second period extended until the late 1920s. Over the course of approximately eight years Stieglitz and O'Keeffe enjoyed the rewards of an exceptionally productive union, sometimes working side by side on identical themes — apples, landscapes, the sky, and New York cityscapes. The last period was, by contrast, a time when tension crept into the partnership. A still relatively young woman, O'Keeffe began to feel constrained and showed signs of a restlessness that eventually took her off to New Mexico. The two photographs of O'Keeffe on pages 108 and 109, stark, black, almost grim, allow one to feel what strains their relationship must have been under. As O'Keeffe later noted, she began at this time to realize that she loved the artist perhaps more than the man.

Just as the imagination roams readily through time, so some photographs and paintings that follow the first images in each plate section jump out of the chronological flow, dwelling either on common subject matter or a stylistic interchange. For the most part, we have tried to focus on irresistible comparisons of subject or form, whether these correspond chronologically or not. On occasion, however, we felt it important to go further than this and suggest deeper, less obvious patterns of exchange.

If all the pairings are eloquent in their own right, they are nonetheless mute and therefore subject to all kinds of speculation and interpretation. The three essays complement the visual evidence with different views of the relationship. Roger Shattuck has in fact approached the pair from two directions, the first in the form of a fable in which he recreates the emotional and creative bonds that united Carl and Miranda, alias Alfred and Georgia. The second part of his essay deals with the reality that underlies the fable and the dynamics of two people's creativity, not only Stieglitz and O'Keeffe's but also that of other artistic couples. The photography historian Belinda Rathbone looks at the relationship through Stieglitz's eyes, while Elizabeth Hutton Turner, an art historian, considers the way it affected O'Keeffe's development as a painter. A selection of biographical highlights compiled by Elizabeth V. Chew takes us by the important landmarks of the two lives and the major art world events that impinged upon them.

This book was conceived and developed over the last two and a half years in conjunction with an exhibition of the same title curated by Elizabeth Hutton Turner of The Phillips Collection in Washington, D.C. The chronology of photographs and paintings at the end of the volume reproduces all works from this show not depicted in the plate section of the book. Using this section as a guide, one can follow the year-by-year development of two artists, both as individuals and as a couple.

9

THE GREAT AMERICAN THING

ROGER SHATTUCK

Carl, the glassblower, was closing his shop in the dusk. A slight man with a shock of gray hair, he looked grim and a little frail as he fastened the shutters. He knew that soon he would no longer be opening the shop in the morning and closing it at night.

People had loved the carafes and pitchers and vases he made as a young man. Then he had begun to display in his shop the pottery and silverware and woodware of many other craftsmen. Carl's shop was small but central, and the craftsmen liked the way he showed their wares. And they often visited his shop because there was something special about the way Carl talked. Sometimes he was like an inspired preacher. Sometimes he went on and on like a great wind. Sometimes he could put magic into words like "spirit" and "freedom" and "feeling." "Beauty begins where thinking ends," he would say. The objects he sold became treasures for the wealthy citizens of the town. Carl himself did hardly any more glass blowing. He said everyone should be able to live content with a few beautiful things. He made many converts.

Now Carl was soon going to lose his shop. For months his trade had dwindled. A great international fair had made people forget about Carl. Many artisans opened their own shops. New fashions influenced everything. And a terrible war had started that changed the way people lived. The landlord said Carl could not stay in the building. As he fastened the shutters Carl sighed heavily. He was not accustomed to being alone. He would soon have to move everything out of the shop. But where? He had no place to go. And he still had so much to do and to say.

In the dusk Carl noticed a young woman carrying a sack and looking at the row of shops. In a firm voice she asked him where to find Carl the glassblower. He made a noise between a bark and a laugh.

"I suppose you have things to show me."

His scorn changed to admiration when he saw the objects in her sack. She had animals and flowers woven out of reeds and grasses. She also had stark, beautiful shapes that did not resemble anything real.

"Who taught you to make these?"

"I was apprentice to the best basket makers. These are my own."

"Why do you come to me?"

"People say you will understand them."

"Bah! People want to get rid of me. What difference does it make now if I understand?"

But Carl could not turn Miranda away. She was dark and resolute like a gypsy. During the few days Carl had left to occupy the shop, he cleared out the pots and carvings and laid out all Miranda's work. Her things combined the jaggedness of bones with the softness of summer clouds. Carl's friends did not say much about Miranda. He let her sleep in the shop. He had a little apartment upstairs. Not many people bought her things. But Carl talked differently now. He talked as if something was beginning in his life, not coming to an end.

Miranda went away for a long time. They wrote long excited letters to each other about what they saw and felt. When she came back, Carl took her into the tiny attic where he had moved. The new place had to be their shop and their home in one. His friends still came to hear him talk and to find out about the dark silent woman who had changed his life. For Carl was working again. He was blowing nude figurines in a bold new style. He said it was really one figure in many poses. Often he did not include the head. He never said who the figurine was supposed to be. But everyone knew. And everyone in town came to see the figurines.

Carl and Miranda were very happy now. For the summers they found a little place in the country next to a lake and invited their friends to visit. Carl always had plans for the future of their group, and he loved to explain the meaning of the things they were making. Miranda remained remote and dignified. She was weaving larger and more brightly colored objects. Once, Carl and Miranda showed their work together. Of course the gossip did not stop. Some people in the town said they had always known Carl was a dirty old man. And they said anyone could tell she was a witch. It would all come to a bad end.

For several years Carl and Miranda lived and worked together. They had become man and wife. Though he was growing old and white, Carl kept his place open. Friends came by to hear him talk about the links between music and beauty, between the beautiful and the spiritual. Wealthy citizens in carriages came to visit his shop and to buy the things he had there. It was as if Carl and Miranda had changed people's taste. Pitchers and glasses had a firmer shape. Many husbands bought her woven flowers to give to their wives.

After a time Miranda became restless. She missed the distant land she had come from and the quiet she had known before. It was never quiet around Carl. He loved noise and made lots of it himself. She could no longer work well in town. Miranda went away for longer and longer periods — sometimes for a whole season, sometimes for an entire year.

No couple can live without quarrels and jealousies. But these two needed one another, and Miranda always came back. His small glass pieces did not look at all like the bigger things she was making now — colored screens, sumptuous hangings. Once every year Carl showed Miranda's things in his shop. She became rich and famous.

When Carl died quietly, a few people in the town believed they had lost a special person, possibly a great man. Even those who had been annoyed by all his talk recognized his gifts. But many of them said that Miranda's work was more beautiful than his. Her strongly colored tapestries conveyed a new sense of form and space. Discussions about how much Carl and Miranda had contributed to the reputation of the town went on and on. But the town council never even named a street or square after them.

Then, a few years after Miranda died, a strange thing happened, not in the town but in the capital city. Someone decided that Carl's glass objects and Miranda's woven works should once again be shown together in one place. Ordinary people as well as learned scholars wanted to find out how much the two had inspired each other and how good their work really was. Can lovers collaborate? Does collaboration make lovers? Or should we forget about all that and just look at the objects? During the exhibit some visitors said they could hear Carl's voice speaking to them from hidden corners of the galleries. Other visitors whispered to one another about a dark Indian-looking woman who walked slowly and alone through the rooms. She must have Miranda's blood in her veins. Or was it Miranda herself?

There still is no Carl-Miranda square — not in their town or the capital. But in many homes you can find flowers woven by Miranda or one of Carl's figurines. Those things have made a difference to the way people live.

. . .

As a couple, Alfred Stieglitz and Georgia O'Keeffe are often portrayed as representing the ideal of a romantic union, artistic and erotic, whose very privacy seemed to radiate notoriety. From cooler accounts we learn the extent to which their selfish plottings, publicity stunts, and occasionally shady dealings reveal two opportunists working in cahoots to exploit others — and each other. The outward facts pose no problem. Their collaboration lasted from 1917 to about 1930 and reached a high point in their joint exhibit of March 1924 at the Anderson Galleries. It is artistically, more than biographically, that their association is difficult to chronicle and to understand.

Anyone concerned with the development of the arts in America must form some opinion of this founding couple of the modern. As much as T. S. Eliot and Ezra Pound worked for a time together toward a new prosody and a new principle of association in poetry, O'Keeffe and Stieglitz supported an art that would be defined by

its American-ness, a quality associated in their day with provincialism. Things were happening fast in the opening decades of the twentieth century, and we should have the story straight.

When Virginia Woolf flatly affirmed that "on or about December 1910 human character changed," she was alluding to the shock of the first Post-Impressionist exhibit in London. It included works by Manet, Cézanne, Gaugin, Redon, and many others. Yet this shock was only the beginning. Between 1905 and 1930, and barely interrupted by the First World War, a surge of experiment carried painting in France, Germany, Russia, Holland, and Italy up to and sometimes across the threshold of abstract art. This radical combination of primitivism and futurism in plastic form gathered force early in the century, while American impressionist painters were having their great period of success and while Robert Henri's Ashcan school of early social realism was organizing independent shows as "The Eight" (1908, 1910). In a period still characterized by the sinuosities of art nouveau style and by the semi-caricaturized ideal of the Gibson Girl, the United States turned out to be surprisingly responsive to the great wave of European modernism — provided it remained European.

The 1913 Armory Show had an even greater impact on New York than the 1910 Post-Impressionist exhibit had on London. Enthusiasts have claimed that the Armory Show opened up America to European innovations the way Commodore Perry opened up Japan to trade with the West. Two-thirds of the 1,300 works were American, but the European rooms drew the crowds, the press, and the hecklers. In spite of many mocking reviews and cartoons, the show was a remarkable artistic, commercial, and fashion success. New galleries offering European art opened in New York, and Cubism, Fauvism, Primitivism, Expressionism, and abstraction began to infiltrate the art schools. When the painter Joseph Albers wrote catalogue copy for a group show at the Addison Gallery in Andover, Massachusetts in 1937, he was repeating a doctrine that had been welcomed since 1913. "Abstract Art is the purest art; it strives more intensely toward the spiritual. Abstract Art is Art in its beginning and is the Art of the Future."

The man who had done more than anyone else to prepare the way for the Armory Show and might have been expected to welcome it called it instead "a circus" and played only a reluctant role on the organizing committee. Stieglitz realized that his small, tastefully arranged gallery offerings of new European artists were being engulfed in one of the earliest blockbuster shows. How is it, then, that in looking back on the years that followed, O'Keeffe did not refer to European tendencies but used the slightly amused expression, "The Great American Thing"? The answer will lead us in several directions.

Stieglitz's Little Galleries of the Photo-Secession at 291 Fifth Avenue, founded in 1905, served virtually as a cover for other activities. He maintained a gathering place for artists and patrons, produced a major art publi-

13

cation called *Camera Work*, developed a growing concern with painting, and created the strong sense of a group with a leader and a high mission. Within a few years the gallery became famous enough to be known simply as 291.

By 1910 Stieglitz had won his campaign to establish pictorial photography — photographs that imitated the motifs and formal arrangements of traditional European painting — as an art worthy of recognition by museums. But at the time of this first triumph he was already in hot pursuit of other causes, primarily in Europe. He came back to New York in 1911 in the full glow of one of his enthusiasms:

> I feel the way Tannhäuser must have felt when he returned from Venusberg and lost his patience listening to his colleagues theorizing about love. There is certainly no art in America today, what is more, there is as yet no genuine love for it. Possibly Americans have no genuine love for anything. But I am not hopeless. In fact I am quite the contrary.[1]

The last two sentences reveal his plan. The first shows at 291 of Cézanne, Picasso, Braque, and African art were the first of their kind in the United States. The critics, the public, and artists responded passionately if not always favorably to these revolutionary exhibits, so much so that by May 1912 Stieglitz could take quite a different stance. "Isn't my work for the cause about finished?" he wrote to the photographer Heinrich Kuehn. Stieglitz was exaggerating, as usual, but he had reason to think that the Armory Show, which opened the next year, was merely following his lead. This second triumph led him to correct his course again — not by going to Europe for new candidates but by affirming American art. The constant convert first mounted an exhibit of his own "straight," that is non-pictorial, photographs to run during the Armory Show and then gave unwavering support and attention to his American artists.

In 1917, in large part because of the war, Stieglitz lost everything — his headquarters, his gallery, *Camera Work*, and the new avant-garde review *291*. It would be years before he found another place to call his own. But just before the catastrophe, as if by some compensating mechanism or benevolent providence, two young artists entered Stieglitz's life and lifted him professionally and emotionally into a new orbit. A twenty-six-year-old New Yorker named Paul Strand began to produce strongly rhythmic photographs that renewed Stieglitz's dedication to photography as an independent artistic activity. And a twenty-nine-year-old Wisconsin farmer's daughter, from her teaching posts in South Carolina and then Texas, sent to New York works that vindicated Stieglitz's new Americanist cause. Georgia O'Keeffe would soon become his inspiration and his competition. The spirit of 291 did not die; it found a new direction. Four years after Stieglitz closed the two famous rooms on Fifth Avenue with O'Keeffe's small first show of drawings and watercolors, he began at the Anderson Galleries a series of exhibits of a group that was to become almost a family. Charles Demuth, Arthur Dove, John Marin, and Marsden Hartley were all Americans. Now approaching sixty, Stieglitz placed his own work

and that of his publicly proclaimed model, consort, and prospective wife at the center of the project.

1921. For the first time in eight years Stieglitz exhibited his own photographs, forty-five of them forming a section entitled *A Woman*. O'Keeffe posed alternately attired (as herself) and stark naked (always headless), sometimes in front of her own strikingly abstract pictures. The photographs spoke most clearly in the way they fused the language of design with the language of eroticism.

1923. *Alfred Stieglitz Presents 100 Pictures by Georgia O'Keeffe*. Swirling, bursting abstractions hung beside closely seen still lifes of fruit and leaves. Marsden Hartley wrote in the accompanying pamphlet that her work was "volcanic" — implying powerful sexuality. Her own statement sounded a note of resolute independence. The critic for the *New York Herald*, Henry McBride, who would soon become a good friend, praised her for being "unafraid."

Later that year, Stieglitz exhibited more than one hundred of his own works, including ten of his first cloud photographs called *Music* and a large number of portraits.

1924. Stieglitz and O'Keeffe's only joint exhibit combined sixty-one 4x5 cloud photographs with fifty-one mostly figurative paintings, many of them very large. The implied equality of photographs and paintings generally persuaded the critics and led to a number of purchases.

1925. *Seven Americans: 159 Photographs and Things* mixed the media even more resolutely than the previous show. Two photographers (Stieglitz and Strand) consorted on equal terms with five painters (Marin, Dove, Hartley, Demuth, and O'Keeffe). It was the largest exhibit Stieglitz ever mounted. By endorsing photography as an art and by certifying the acceptance of his protégée O'Keeffe as the unchallenged peer of the men, it marked the apogee of his career as an artist and an impresario.

Still hard at work, he wrote to the writer Sherwood Anderson, "I feel I am still needed on the bridge." He did work on after 1925 in New York and at Lake George, if not quite on the bridge. But the spirit of 291 made its most important contributions between 1921 and 1925, after it lost its headquarters and twenty years after its founding. How can we explain this vigorous survival during a period of rapid social and cultural change?

Stieglitz's initial project of leading a group toward the religion of art had little originality other than its association with the relatively new medium of photography. The value he attached to purity of means and to constant experiment, and his ostentatious refusal to yield an inch to commercialism, had their roots in European art for art's sake doctrine and in Symbolism. Maurice Maeterlinck, the philosopher Henri Bergson, and Vasili Kandinsky had impressed him deeply with their writings on the spiritual. Why then did Francis Picabia, the unofficial spokesman for the most rebellious faction of the European avant-garde during the Armory Show, declare that nothing in Europe could compare with what Stieglitz was doing in New York?

I believe that what impressed Picabia was Stieglitz's extroversion, the perpetual group discussions that spilled over into daily round table lunches at a local restaurant. Stieglitz had hit upon the awkward yet sturdy counter-

institution named 291 — clubhouse, chapel, laboratory, and salon as it was variously called — because of his compulsive need to collaborate. Stieglitz lived and worked in public, and the impresario in him sometimes overwhelmed the artist. It was the photographer Edward Steichen, fifteen years his junior, who conceived, designed, and provided the early contents of *Camera Work*. Steichen also promoted the idea of the Photo-Secession Galleries in 1905 and discovered the space for it in the studio he was vacating at 291 Fifth Avenue. In the following decades Stieglitz worked closely with a whole contingent of artists and writers, principally with Paul Haviland, Marius De Zayas, and Paul Strand.

But the O'Keeffe-Stieglitz collaboration appeared to overshadow and outlast all the others. The famous couples of art offer us few useful precedents or comparisons for this prickly union. The extramarital literary and domestic union between George Eliot and George Henry Lewes brought them closer and lasted longer than that of the American couple. Robert and Sonia Delaunay reinforced one another's experimental painting and for a time headed an informal household of poets and artists. But the dynamics of artistic life in London and Paris differed widely from those in New York. We marvel at O'Keeffe's relation to Stieglitz, almost thirty years her senior, because she resisted submission. In maintaining her personal and artistic independence, she also gave impetus to his work. Their principal collaboration took place during the extended sitting for the *Portrait* series. For over a decade she increasingly posed herself for Stieglitz's voracious camera-eye.

I am prepared to concede that there is little new under the sun. Yet I recognize something unique in the ten-year working union of O'Keeffe and Stieglitz. In the most intimate poses of *A Woman* — some images in that exhaustive exploration reduce her to a direct frontal view of heavily furred pudenda — she never loses her dignity as a human being. When the time comes in 1927 for her to pay public tribute to Stieglitz, she paints his name into the New York skyline of *Radiator Building — Night, New York*. It is not a neon sign as some have suggested; an oblong, ruby-colored emanation reveals his name hovering below a single vivid star. Such a tiny point of light punctuates many of her compositions, both figurative and abstract, and marks an intersection between form and meaning. O'Keeffe and Stieglitz acknowledged each other artistically in powerful ways.

The sexual excitement that obviously drew them together at the start deserves recognition primarily because the intimacy it provoked modified their artistic development, separately and together. The electric current around them in New York and at Lake George was generated by a dynamic of strong differences. Beyond the contrasts in age, sex, and culture, Stieglitz's gregariousness and exhibitionism sometimes grated on O'Keeffe's need for privacy. One of her descriptions of Stieglitz conveys the tensions among which they lived together and, for a surprisingly long period, worked together.

16

> His power to destroy was as destructive as his power to build — the extremes went together. I have experienced both and survived, but I think I only crossed him when I had to — to survive.[2]

In the 1990s some museums are beginning to rehang their twentieth century collections, interspersing paintings, photographs, and graphic work. I wonder if, in such an integrated gallery, a sensitive eye that is unfamiliar with the historical background and ignoring the labels would spot a connection between O'Keeffe's and Stieglitz's works. Many other loops and links in modern art, like the upended picture plane, the Cubist grid, and biomorphic forms, would probably strike that eye first. Yet I believe there is a fruitful line of inquiry here. Let us try to look at several works without necessarily following prior art-historical promptings.

The title of Stieglitz's familiar photograph *The Steerage* (1907, page 28) implies a document that comments on social class and economic condition. Its depiction of respectable poverty in shawls and skirts soon yields, however, to juxtaposed diagonals with circular shapes at key points and to dramatic contrasts of light and dark. An even more defiant combination of content and composition strikes us in O'Keeffe's painting *Black Abstraction* (1927). The near-photographic outline of thigh and calf confounds the title and then reveals an ominously black, concentrically circular pattern overflowing the frame. The bright dot functions as an almost ironic node to pin together the two parts — figurative and abstract, photographic and painterly. The graceful line of what I read as an allusion to O'Keeffe's own body photographed by Stieglitz achieves secure coexistence with the pulsing target shape, like a dark halation trying to engulf the leg.

The above description of *The Steerage* does not conflict with Stieglitz's account of how he found and caught "shapes related to each other" as well as a view of "the common people." But my interpretation of *Black Abstraction* departs from O'Keeffe's explanation of the painting as images of a skylight, and arm motion in a dark room occurring just prior to anesthesia for an operation. Whatever the genesis of the painting, I see its contrasting elements as a symbolic double portrait of herself and Stieglitz. Her own words reinforce that interpretation. Soon after writing the lines quoted at the end of the previous section, O'Keeffe continues with two sentences that illuminate the menace and the exaltation reconciled in *Black Abstraction*. She is still talking about Stieglitz.

> There was a constant grinding like the ocean. It was as if something hot, dark, and destructive was hitched to the highest, brightest star.[3]

In *Black Abstraction*, O'Keeffe alludes to the *Thighs and Buttocks* series (1923), a little-known segment of the *Portrait* photographs. These photographs vary an *a tergo* motif that Stieglitz repeated with greater insistence in the 1932 *Buttocks and Thighs* series. Shot close up and severely framed to exclude head and extremities, these rear-view photographs represent an ambiguous mix of naughtiness and abstraction. In the elegant composition *Line and Curve*, O'Keeffe acknowledged the abstraction and rejected the naughtiness of the *Thighs*

and Buttocks photographs even though she had been and would again be a willing party to them. The pictorial evidence tells us something about the width of the gap between O'Keeffe's life as Stieglitz's model and her life as an artist.

What is the significance of the fact that, with limited exceptions, the human figure disappeared from their pictures? It happened for O'Keeffe after the 1917 watercolor *Nude* series. For Stieglitz, except for the portraits, it happened after *The Steerage*. The bulk of their work depicted landscape, cityscape, and still-life motifs all tending strongly in the direction of pure form and abstraction. Even animals are excluded except in the inanimate form of bones. More than context or subject, formal composition offers the most revealing way in which to compare and group their works.

When contemplated side by side, O'Keeffe's handsome *White Abstraction (Madison Avenue)* (1926, page 101) and Stieglitz's *Spiritual America* (1923, page 100) seem to acknowledge each other's total nuances, visual geometry, and elusive-allusive titles. I find no evidence that O'Keeffe was thinking about the Stieglitz composition when she painted hers. But once made, the association abides. Even more starkly than *The Steerage*, *Spiritual America* presents a clearly etched linear geometry contrasting with subtle nuances of texture and shadow. No other title of Stieglitz's insists so emphatically on the symbolic interpretation of a close-up. We are approaching the blurred universe of Antonioni's film *Blow Up*, in which proximity brings not recognition but disorientation. Does the title imply that the sturdy white horse Stieglitz referred to as a gelding, and whose privates he shows us as carefully framed as O'Keeffe's hands, stands for the deprived state of artistic sensibility in the United States? What does it mean that the horse is unhitched and the traces attached above the breaching to the hip straps? There's an obscure joke or curse in the framing and naming here that recalls works by Picabia and Man Ray.

Considered without its full title, O'Keeffe's *White Abstraction* approaches the starkness of Malevich. With "Madison Avenue" pinned on, it tempts one to look for witty realism, like Mondrian's *Broadway Boogie-Woogie*. But I believe O'Keeffe was simply identifying the figurative origin of the formal composition. And then we find the pattern or remember it portrayed in *New York, Night* (1928–29). Starting from the dark mosaic of cityscape with its partially masked diagonal, white rose window, and bright pagoda, she has transfigured the colors, eliminated the massive and detailed signs of city life, and retained only the major stress lines and the round nodal point displaced downward. These two paintings show us one of the clearest versions of her bifocal vision. She could paint both ways, abstract and figurative, convincingly.

On one rare occasion when O'Keeffe decided to leave her vegetarian world and paint an animal, she posed and framed the poor creature more radically than Stieglitz had done with her body. I doubt that *Cow* (1922), if found unidentified in an attic, would be attributed to O'Keeffe. Dove seems more likely as the creator of this strange emblem of the bovine, bellowing at the moon or gagging on its immense tongue. On first encounter it

provokes a double-take of delayed recognition. Then one discovers the magnificent eye, schematic and terrified, and the black snout-like shape turning into a purely formal element on the green ground. *Cow* is one of O'Keeffe's most impressive and puzzling paintings.

At this juncture Stieglitz had just begun photographing clouds. Many European painters and photographers had preceded him. Stieglitz offered his works simultaneously as straightforward documentary images of nature, as lyric expressions of personal states of feeling, and as formal compositions as controlled as any painting. Since there was nothing candid or spontaneous about these photographs, the first claim and the last stand up best. Any expression of emotions had to be interpreted not as momentary and impetuous, but as an aesthetic attitude built up toward natural forms over a long period of time. Cumulatively, Stieglitz's several cloud series achieve a unity in variety that the series of O'Keeffe portraits achieves only intermittently.

It was an intense awareness of formal relations in their pictures that first gave O'Keeffe and Stieglitz the confidence to work alone on the frontier of their respective arts and then brought them together as associates. If it is possible to identify a common element of design in O'Keeffe's *Evening Star* series (1915–16, pages 74 and 129), I would attribute it in part to European influences and in part to a widely recognized system of teaching design in the United States. When O'Keeffe referred to "the idea of filling space in a beautiful way," she was repeating principles identified with Japanese Notan. She had heard about these "darks and lights in harmonic relation" directly from the artist and teacher Arthur Wesley Dow at Columbia Teachers College and from one of his students in Virginia. O'Keeffe would read the six chapters on Notan in Dow's hugely successful book, *Composition: A Series of Exercises in Art Structure* (1899; revised 1913), and she probably communicated his ideas to Stieglitz and his circle. Dow praised the elements of composition in Notan by emphasizing their ability to create visual music. Stieglitz called the earliest series of cloud photographs *Music* (pages 38, 46, and 134). O'Keeffe used the same title for a set of rope-like pink and blue abstractions in 1919 (pages 35 and 131). Whatever the source for their devotion to formal design in their pictures, during the crucial years of their association Stieglitz and O'Keeffe sometimes worked as close together as mountain climbers or trapeze artists.

For over a decade the founding couple of American art collaborated in a stubborn effort to hold out against invasion from abroad and to keep American art safe for Americans. In first welcoming and then resisting Post-Impressionism, Fauvism, Cubism, Expressionism, and Futurism, Stieglitz and O'Keeffe were maintaining the position stated by Stieglitz in a letter to Steichen: "Despite the Ballyhoo at the Armory, 291 is still the storm center."[4] It sounds like a fit of petulant jealousy, but the claim had merit. Even though the 291 Gallery folded four years later, its spirit lived on in a series of chauvinistic exhibits at the Anderson Galleries. The brief autobiographical note for Stieglitz's 291 show of his own

new works including *A Woman* opened with two defiant sentences: "I was born in Hoboken. I am an American." The announcement for the 1923 exhibit of one hundred pictures identified the artist as "Georgia O'Keeffe American." When the whole 291 group showed their work together in 1925, the event was publicized a little belligerently as *Seven Americans*. In 1929 Stieglitz finally found a tiny space in which to work and talk and show a few things. He named it An American Place. What O'Keeffe named "The Great American Thing" gradually took shape in the environs of a New York collaborative enterprise that eventually lost its space but kept its spirit.

The history of American literature generally accepts the Concord Transcendentalists as the first significant literary movement or school to assemble a set of talents and gifted writers and to declare full independence from European models. Emerson's early addresses and essays, particularly *The American Scholar* and *Self-Reliance*, read like manifestoes of the movement. After the first phase of promoting pictorial photography and the second championing European avant-garde art, Stieglitz's 291 entered a third period in which it fulfilled in the arts much the same function as that of the Transcendentalists in literature. Stieglitz combined a stirring message of artistic independence with a vague spirituality that never quite became a religion. His ideas in many ways resembled those of Emerson and not only influenced the artists' attitude toward their art but also impressed successful writers about America, like Sherwood Anderson, Waldo Frank, Paul Rosenfeld, and Lewis Mumford.

The most surprising element of the comparison between the Transcendentalists and the later years of 291 lies not in the general similarity of circumstances and ideas but in the association of two specific incidents. Among the few people to whom Walt Whitman sent the first slender 1855 edition of *Leaves of Grass* was Emerson. Not many recipients reviewed the book or responded to the author. Emerson wrote back a historic letter to the boldly American poet and warmly praised his undertaking. From Concord, the Dean of Transcendentalists and celebrated lecturer sent this message to the unknown thirty-six-year-old poet: "I greet you at the beginning of a great career." It constitutes one of the most stunning acts of recognition in the history of literature.

In the history of American art the words Stieglitz said in 1916 to Anita Pollitzer on first looking at O'Keeffe's drawings stand as the approximate equivalent of Emerson's greeting to Whitman. "At last, a woman on paper."[5] Stieglitz welcomed O'Keeffe as the unspoiled voice of America, a child of the West, a kind of savior whose very sex would help rescue art from the embrace of European influences and doctrines. The cosmopolitan Stieglitz converted to an ethnic Americanism in great part because of O'Keeffe's non-figurative compositions. They hid their many sources (including European) as effectively as Whitman hid his. But whereas the Emerson-Whitman encounter led to no further exchanges, the Stieglitz-O'Keeffe encounter detonated a burst of artistic activity on both their parts. As a result of their union of equals for over a decade, we will do well to regard them twice — separately and together.

Beyond the vast bibliography on O'Keeffe and Stieglitz, a few recent publications have helped me greatly in writing this essay: Bram Dijkstra, "America and Georgia O'Keeffe," in *Georgia O'Keeffe: The New York Years* (New York: Callaway/Knopf, 1991); Benita Eisler, *O'Keeffe & Stieglitz: An American Romance* (New York: Doubleday, 1991); Sarah Greenough and Juan Hamilton, *Alfred Stieglitz: Photographs and Writings* (Washington, D.C.: National Gallery of Art, 1983); Sarah Whitaker Peters, *Becoming O'Keeffe: The Early Years* (New York: Abbeville, 1991). Benita Eisler, Merry Foresta, and Patricia Lambert contributed valuable comment and criticism.

[1] Letter to Sadakichi Hartmann, December 1911; see Greenough and Hamilton, pp. 193–194.

[2] Georgia O'Keeffe, *Georgia O'Keeffe: A Portrait by Alfred Stieglitz* (New York: The Metropolitan Museum of Art, 1978), p. 17.

[3] Ibid.

[4] Letter of February 1913; see Eisler, p. 109.

[5] As noted by Anita Pollitzer in a letter of January 1, 1916; see Clive Giboire, ed., *Lovingly, Georgia: The Complete Correspondence of Georgia O'Keeffe and Anita Pollitzer* (New York: Simon & Schuster, 1990), p. 115.

I believe I would rather have Stieglitz like something —

anything I had done — than anyone else I know of....

If I ever make anything that satisfies me even so little —

I am going to show it to him to find out if it's any good.

Georgia O'Keeffe, 1915

Those drawings — how I understand them.

They are as if I saw a part of myself....

Alfred Stieglitz, 1916

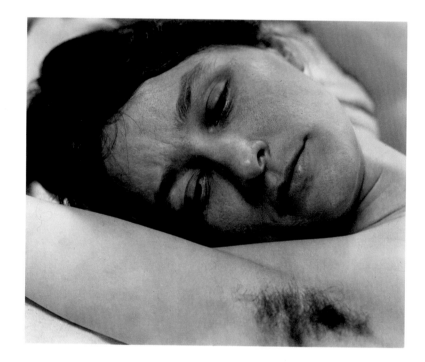

Georgia O'Keeffe: A Portrait – Head, 1918

Abstraction IX, 1916

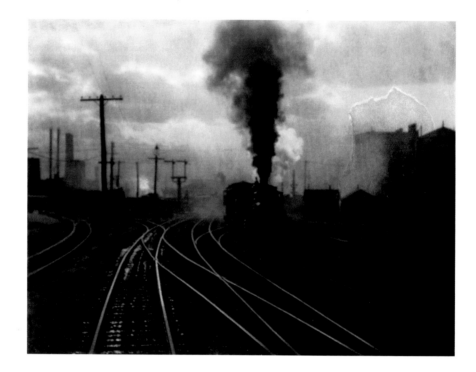

The Hand of Man, 1902

Train at Night in the Desert, 1916

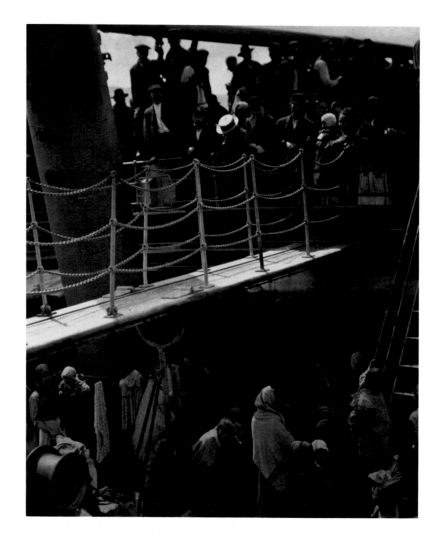

The Steerage, 1907

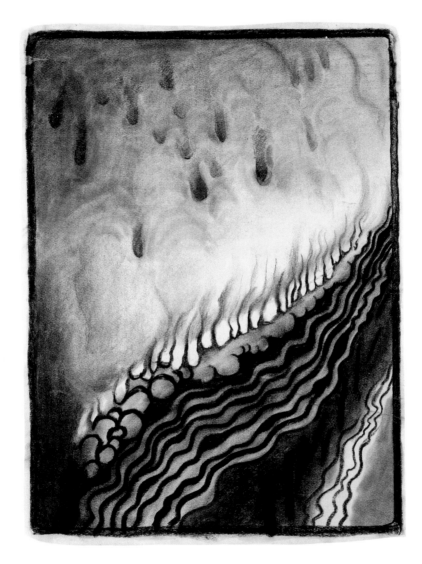

Special No. 9, 1915

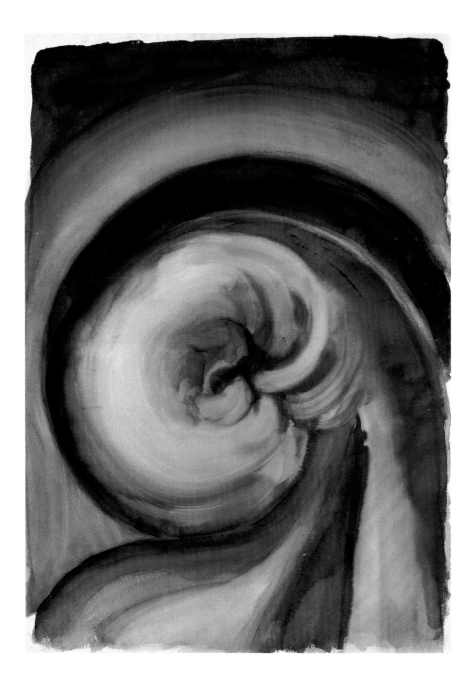

Blue I, 1917

Georgia O'Keeffe: A Portrait, 1918

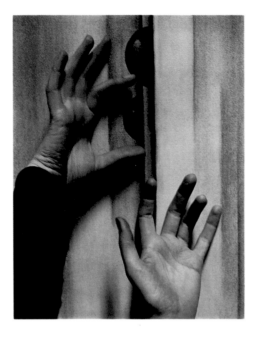

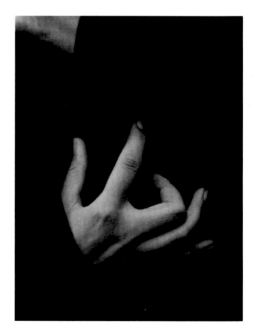

Georgia O'Keeffe: A Portrait – Hands, 1919 Georgia O'Keeffe: A Portrait – Hands, 1918

I never realized that what she is could actually exist —

absolute Truth — clarity of vision to the highest degree.

Alfred Stiegliz, 1918

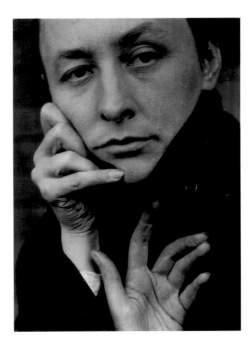

Georgia O'Keeffe: A Portrait – Hands and Face, 1918

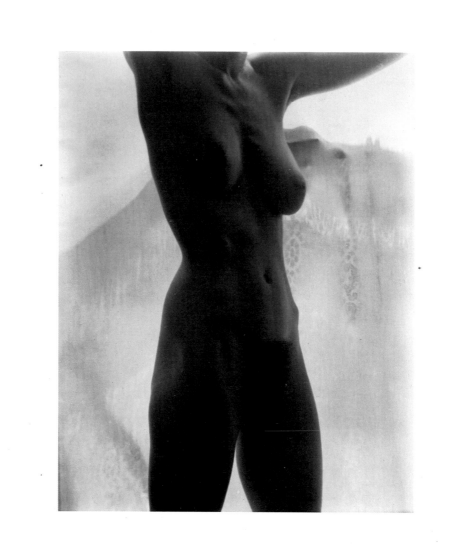

Portrait of Georgia O'Keeffe, 1919

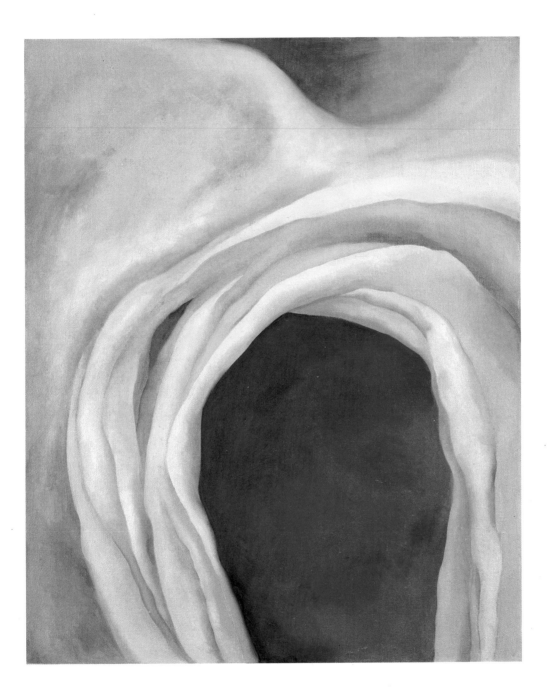

Music – Pink and Blue I, 1919

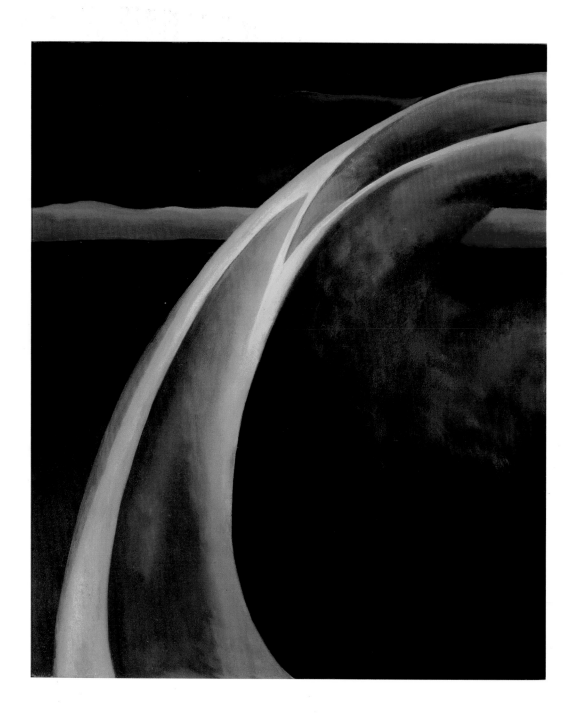

Orange and Red Streak, 1919

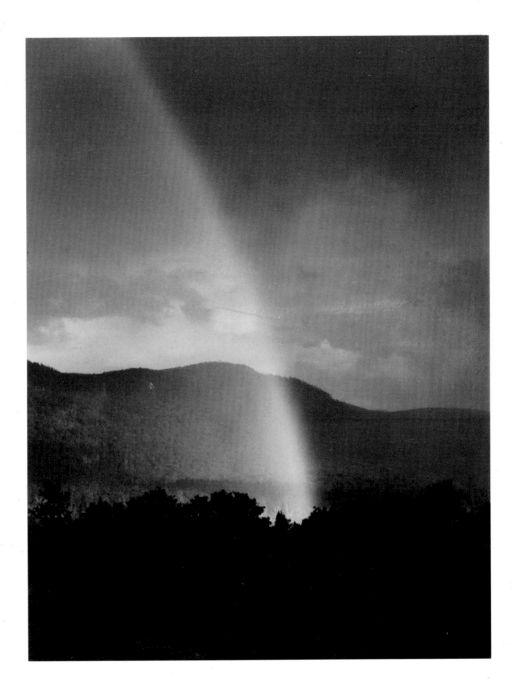

Rainbow, Lake George, 1920

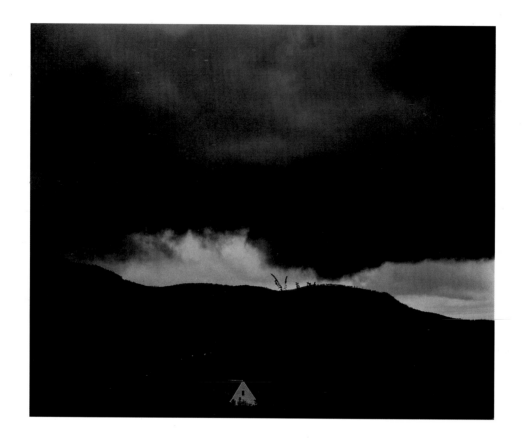

Music – A Sequence of Ten Cloud Photographs, No. I, 1922

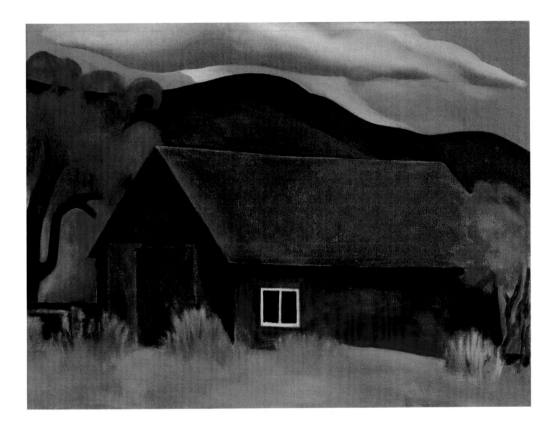

My Shanty, Lake George, 1922

Later Lake George, 1934

Lake George Window, 1929

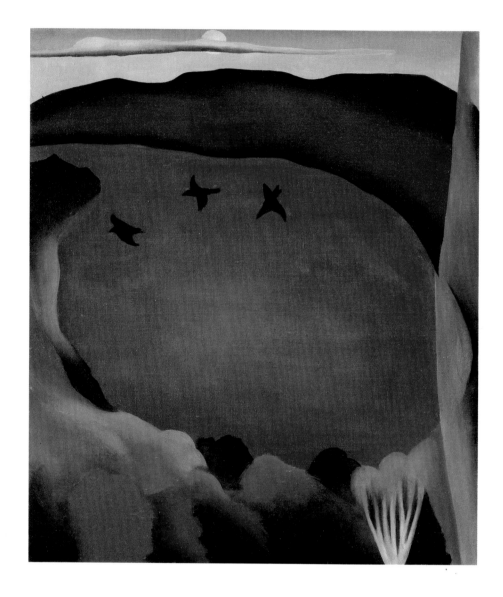

Lake George with Crows, 1921

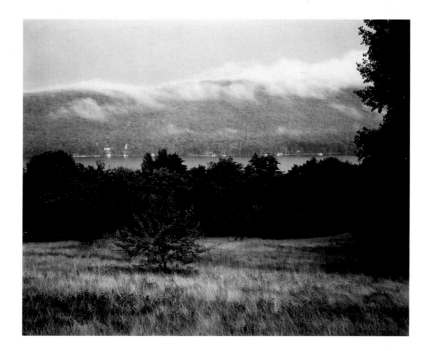

Later Lake George, 1931

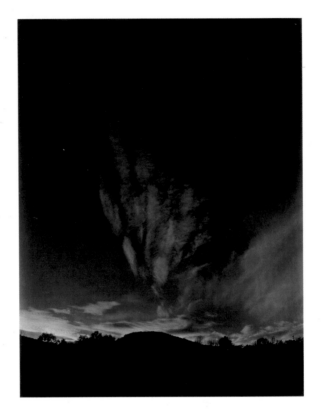

Mountains and Sky, Lake George, 1924

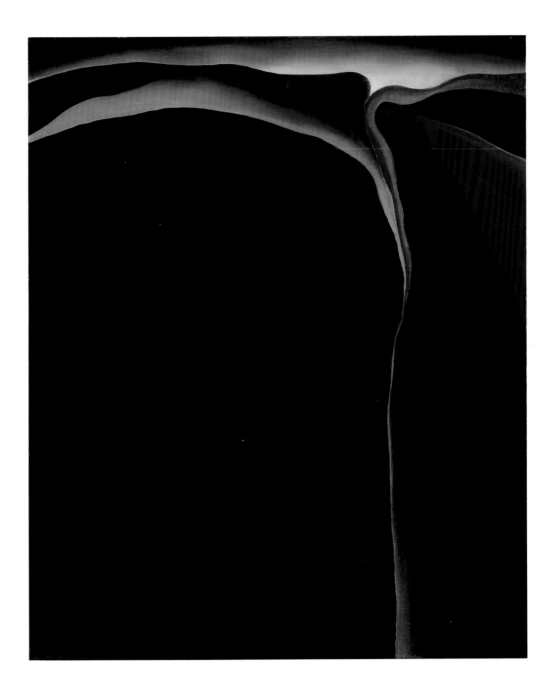

Dark Abstraction, 1924

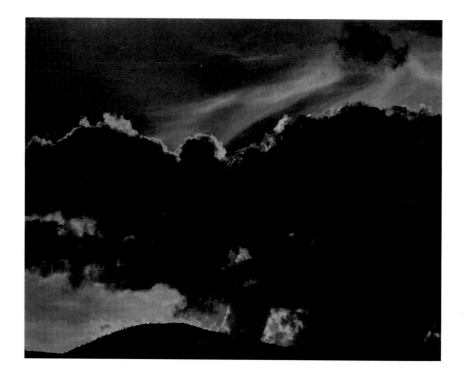

(clockwise from top) Songs of the Sky, 1924

Music – A Sequence of Ten Cloud Photographs, No. V, 1922

Songs of the Sky – Portrait of Georgia No. 2, 1923

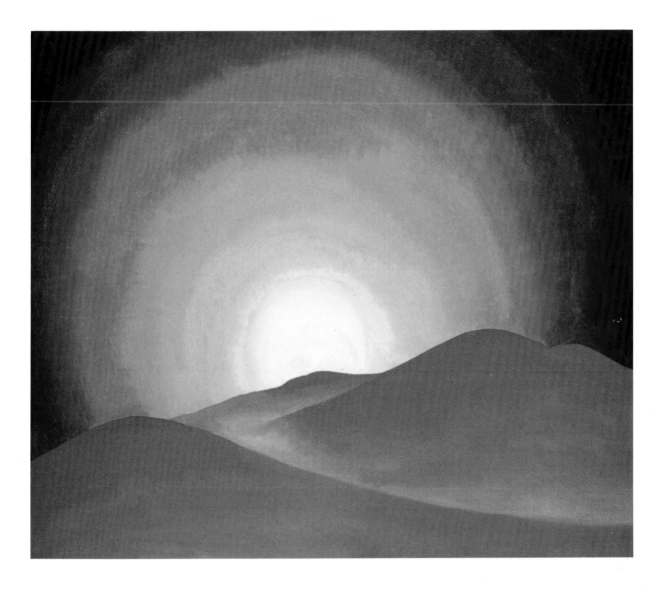

Red Hills, Lake George, 1927

LIKE NATURE ITSELF

BELINDA RATHBONE

In a shady copse reclines a plump young woman, dressed from neck to toe in a country outfit suitable to an outing at Lake George on a summer afternoon in 1893. Her arms upraised, she cradles her head in her hands, languidly resting on a pair of boat cushions. Beside her an inkwell and a handful of fresh envelopes hint at the plotting of an announcement. Two straw boaters — his and hers — conspire together on a black camera case. Alfred Stieglitz is at the view-finder. His model, and future wife, Emmeline Obermeyer, appears to be in the midst of a prenuptial daydream.

It is immediately obvious how greatly this image differs from the celebrated portraits Stieglitz made of Georgia O'Keeffe twenty-five years later. What is equally interesting, but less apparent, is their similarity. We note that the subject's pose is one Stieglitz never tired of, but only wanted to frame more closely. We also see that from his earliest years as a photographer Stieglitz was interested in portraying a woman as his private avenue into the world of nature and, even more specifically, to his beloved Lake George. In order to study the nature of O'Keeffe's impact on Stieglitz's art, therefore, we should be attentive to Stieglitz's original and abiding interests, not dormant in this picture, but merely at an early stage of development.

Once settled down from his student years in Europe in 1890, Stieglitz invariably found his subject matter close to home. Whether in New York or Lake George, in the spirit and tradition of the nineteenth-century amateur he left the famous subjects to commercial photographers and turned his attention to personal and private matters. In particular, he photographed the women in his life, especially those of his family who congregated at the rambling Queen Anne-style "cottage" at Lake George every summer. His mother, his sisters, his cousins, and his nieces were constant subjects, relaxing on lawn chairs after a game of tennis, playing chess, sewing on the sunlit porches, or dozing over a book by the fire.

Compared with the work of his contemporaries — partners in the crusade for "naturalistic" photography —

49

Stieglitz's photographs appear to be of modest ambition and simple taste. Even by comparison to the work of Gertrude Käsebier and Clarence White, who shared Stieglitz's contempt for artificial effects and hackneyed poses, Stieglitz's photography, in both approach and execution, is still more pure and precise, and seemingly effortless. While his fellow Photo-Secessionists staged tableaux of domestic scenes loaded with moral implications and pointed references to the history of painting, Stieglitz focused his efforts on rendering those events that occurred spontaneously around him. Even while these early photographs might suggest the setting of a narrative, that narrative would be unmistakably contemporary. While other photographers posed their models in the landscape nude or in diaphanous drapery, strumming harps, blowing bubbles, or merging with twisted pine trees, Stieglitz's women are out on the porch reading *The Evening Post*.

Stieglitz never reached for the biblical or mythical account of womanhood. But this is not to ignore the fact that he harbored his own idealized vision of the feminine. He was forever dedicated to the notion that woman was in closer touch with nature than man, that through the workings of her body she had an implicit understanding of nature's mysteries. As such she was a medium between man and nature that he could hardly live without. In particular she could connect him more closely to the core of his creative and feminine self.

Not long after his marriage, Stieglitz realized that he lacked such a willing medium in his wife. In place of that connubial fantasy, he continued his quest by falling in love with women who epitomized naturalness and free self-expression, but were perpetually out of reach. In 1895 it was Eleonora Duse, the Italian actress, who so enraptured Stieglitz that he took a front-row seat every night of her performance of *Camille* in New York. Though not a classic beauty, Duse was an actress of tremendous nuance, with an extraordinary ability to transform her appearance without costume or makeup. Ellen Terry's first impression of Duse was that she had "the walk of a peasant, fine and free. She has the superb carriage of the head, which goes with that fearless movement from the hips. And her face! There is nothing like it, nothing! But it is as the real woman, a particular woman that Duse triumphs most."[1] Perhaps not since he was a student at the Berlin Polytechnic, when he fell in love with the paintings of Rubens, especially those of the artist's wife, the voluptuous Hélène Fourment, had Stieglitz witnessed such a perfect realization of his ideal woman. Meanwhile, Emmeline — peasant-like but not free, buxom but not voluptuous — rubbed her indelible impression into his daily life. A photograph of a Rubens painting decorated the newlyweds' bedroom. With Fourment on his wall and Obermeyer in his bed, Stieglitz lived with a conflict he had yet to resolve.

When his first and only child, Katherine, was born in 1898, Stieglitz began the longest and least successful project of his career, *The Photographic Journal of a Baby*. Beginning with infancy, he hoped to capture and shape every stage of her growth and development to womanhood — the germ of a project that he would later articulate as a portrait of a woman "in the flux of life." For the time being, Stieglitz seemed unable to avoid the sentiments of the typical doting father. He photographed his daughter nursing in her mother's arms, yawning

(Bedtime), face to face with a cow *(A Summer Walk)*, or waist deep in the lake *(The Swimming Lesson)*. Later on, as Kitty matured, the portraits shifted from sentimental records to hostile confrontations. As the father persisted in perceiving his daughter as a child of nature, draping a branch of flaming red maple over her lap (in autochrome), or tucking a potted plant under her arm, she resisted him with her gaze. Compared with her flirtatious and engaging female cousins, Kitty was no easy collaborator, and her expression had no repertoire. Torn between his search for truth through photography and his disappointment in Kitty's limitations, Stieglitz ran aground.

If Stieglitz harbored a fantasy of his natural woman, so far his fantasy had no object, no proof that such a thing could exist in his world — a world, it must be emphasized, that he had no intention of leaving. That she did not immediately appear allowed Stieglitz the several years he needed to pursue a goal as important to him as his own photography. Determined that photography belonged in the same discussion as the pressing issues of modern art, and painting in particular, Stieglitz began publishing the deluxe art journal *Camera Work* in 1902, and established the Little Galleries at 291 Fifth Avenue two years later. As America's most visible and versatile spokesman for the European avant-garde, Stieglitz had little time for photography. Surrounding himself with the work of Picasso, Braque, Kandinsky, Rodin, and others, he pondered the explosive variety of modernism and the meaning of abstraction. While Stieglitz was confident that photography was a vital part of this mix, his own work was out of step with it, and he had no idea how to get it back in. In 1907 he made what he considered to be, and broadly advertised as, a Cubist photograph, *The Steerage* (page 28), but this was an isolated example that he was unable to follow with another. Essentially, except to photograph the artists and writers who congregated at 291, and occasional attempts to photograph free-spirited women with whom he was briefly infatuated, Stieglitz had retired his camera.

With the Armory Show in 1913, Stieglitz's role as crusader was suddenly diminished. He was no longer alone as the champion of modern art in America; the field was getting crowded. Mabel Dodge, doyenne of Greenwich Village radicals, drew artists from the Stieglitz camp south on Fifth Avenue, while the Walter Arensbergs gathered the growing ranks of Dadaists to the Upper West Side. Furthermore, several of the artists Stieglitz had represented found another outlet in Agnes Meyer's Modern Gallery, and he bemoaned the pressure put upon him by those who remained to compete in the increasingly commercial New York art world. By the mid-1910s he was thoroughly bored with his fellow Photo-Secessionists, and they had also abandoned him, gathering now around the more reliable leadership of Clarence White and his newly established school. Subscribers to *Camera Work* decreased from 350 in 1905 to 37 in 1915. Every new issue drew outrage among fellow photographers. Stieglitz was ready for the end. "There won't be any more issues of *Camera Work*," he wrote to his friend, the photographer Anne Brigman three years before the last issue; "the material in the photographic world is very meager, and I don't feel as if I can afford to spend my life on repetition."[2]

Stieglitz's declining hope for American photography was arrested just before *Camera Work* came to a close by his friendship with the young photographer Paul Strand. Stieglitz was astonished by Strand's ability to incorporate the lessons of abstract painting into photography. In his abstractions of bowls, and his bold composition of a white fence, Stieglitz perceived for the first time a link between photography and the new painting, a feat he had believed was possible but had been unable to visualize. Perhaps most of all, Stieglitz was struck by Strand's candid street portraits, which he described excitedly as "brutally direct — devoid of all flim-flam, or of any ism."[3] To this determined young artist he devoted the better part of the last two issues of *Camera Work*. As if to signal its full circle, the magazine had returned to photography, and photography had changed.

By the summer of 1915, after a winter of "Battles Royal" at 291, Stieglitz had grown tired of public life. With Emmeline on a tour of New England with a friend, and Kitty at summer camp, he found himself blissfully alone at Lake George. Always up to date in his reading, Stieglitz had recently found solace in the philosophy of Henri Bergson and his seminal work, *Creative Evolution*. Bergson's belief in the inevitability of change as an essential element of creativity helped Stieglitz to grasp the meaning of change in his own life. Appealing to Stieglitz's deepest instincts, Bergson postulated that every individual was constantly moving through successive births of awareness. His philosophy prescribed a condition that Stieglitz was longing for, to be overtaken by a force greater than himself, by anarchism and the essence of sex. Taking literally Bergson's prescription for "bathing in the full stream of experience," that summer Stieglitz reveled in every nuance of the lake, the trees, and the sky. "I never grow tired of watching the water," he wrote to his secretary, Marie Rapp; "there seems to be no end to the varied feelings it calls forth in me." He confessed that he was in "a queer mental condition,"[4] and that he had an urgent new fantasy — to swim alone, nude, in the lake at night, an idea he invested with great daring and metaphoric weight, undoubtedly related to his quest for the feminine element so badly lacking in his life. By mid-September Stieglitz had indulged in his moonlit swim. "It was wonderful," he wrote ecstatically to Rapp, "Real freedom — a real touch with nature at its best — its finest. And the run over the grass — amongst the trees — the touch of the night air on the wet body. . . . Why can't life be as pure as this?"[5]

As if to answer his question, a young artist named Anita Pollitzer arrived at 291 with a roll of drawings by her former classmate Georgia O'Keeffe on Stieglitz's fifty-second birthday, New Year's Day 1916. The full implications of Stieglitz's viewing of O'Keeffe's work were far from understood by him at this first encounter. But given what we know of Stieglitz's dramatic shift in mood from his highly visible public life to his readiness to retreat into the private realms of the senses, we might now look upon O'Keeffe's entrance into his life as nothing less than a miracle of timing. "Those drawings," he wrote to her later, "how I understand them. They are as if I saw a part of myself. . . ."[6]

O'Keeffe's drawings were of charcoal — in bold strokes suggestive of violent waves, whirlpools, high winds, or flames. Having no precise subject matter, they also seemed to suggest an equivalent to the artist's interior self,

and in their particular forms Stieglitz saw an unabashed expression of female sexuality. This woman was un-afraid of self-expression and unafraid of her range in a way that Stieglitz had never encountered in a visual artist. Perhaps only on stage in the work of Eleonora Duse or Isadora Duncan had he witnessed its equal. Finally, at fifty-two, he had discovered a woman who performed in his own medium: paper.

Without hesitation, Stieglitz decided to include O'Keeffe in a group show at 291 in the spring of that year. Armed with his own beautifully modulated photographs of her drawings, and the memory of her brief visit to New York in June, Stieglitz retreated to Lake George for the summer of 1916. There he continued his midnight swims as well as his annual "dips" into Goethe's *Faust*, "which seems to contain the whole universe," as he told Marie Rapp.[7] He confessed to Paul Strand that his main occupation was "plain loafing — lounging about — watching the Lake." He felt numb — "as if paralyzed."[8]

In fact, Stieglitz was not inactive, but his photography that summer was perhaps too tentative to share with his fellow photographer. Affected both by growing despair over his unhappy family life and the thrills of escaping it, Stieglitz pursued his art haltingly. Attempting to express his feeling of oneness with the lake, he hovered over the water with his camera, casting a looming, distorted shadow of himself, a monster of pathos, lunging toward the eternal feminine. In his desire to see more clearly, he moved upstairs to a new bedroom. "It faces the Lake," he told Marie Rapp, "from my bed I see treetops and through the leafless branches I get glimpses of the Lake, and I see the stars at night and I can see the sunrise."[9]

Throughout the summer of 1916 Stieglitz also wrote to his newest correspondent, Georgia O'Keeffe, now in Texas. Although we are unable to read the many letters they exchanged that summer, those they wrote to inti-mate friends serve as probable substitutes. Their excited descriptions of the changing weather that summer and the feelings it called forth in them, one writing from upstate New York, the other from the Texas panhan-dle, are almost interchangeable. The day after a package of drawings arrived from O'Keeffe, Stieglitz wrote to Marie Rapp of the lake "and the rustle of the leaves, swaying branches — great music."[10] At the same time, O'Keeffe wrote to Anita Pollitzer of the big Texas sky "just blazing — and grey-blue clouds were rioting all through the hotness of it."[11] It is in passages like these that we begin to understand what Stieglitz meant when he wrote to the painter Arthur Dove two years later that he and O'Keeffe were "at least 90% alike,"[12] and that they were both "either intensely sane or mad children — it makes no difference."[13]

When O'Keeffe arrived in New York the following spring, on the occasion of her first solo exhibition (and the last exhibition ever to be held at 291), she saw Paul Strand's photographs for the first time and was immedi-ately struck by the explicit reference they made to modern painting. Hastily, Stieglitz made his first attempt to bridge that gap in his own way — by making his first portrait of O'Keeffe. Standing at the center of one of her own effluvial drawings, with her quizzical nose and arched brow, she looks upon the photographer as if she had known him all her life.

In June 1918 O'Keeffe returned to New York, where Stieglitz had promised her a studio and a place to live. Within a few days he left Emmeline to share it with her. Finally Stieglitz had the subject he had been looking for — a woman who not only moved with the grace of a tall reed in a gentle breeze, but whose emotional immersion in nature was a match for his own. Learning as much about herself as Stieglitz was learning about his photography, O'Keeffe submitted without reserve to the creation of her portrait, with a repertoire equal to his needs. Now, the notion of a serial portrait contained the subtleties of Bergson's thought. Rather than the obvious chronicle of a girl growing up, this was a portrait of a mature woman, an artist, "in the flux of life." In her range of expression, in the freedom with which she moved from nudity to dress, in the confrontation of her gaze, O'Keeffe was equal to an actress in the role of a great modern heroine. Always unmistakably herself, she was also implicitly aware of the variety of her many selves. "I'm photographing," Stieglitz wrote to Anne Brigman, "I wish you could see. — I know you would greatly enjoy. — no tricks. — no fuzziness. — no diffusion. — no enlargements. — clear cut sharp heartfelt mentally digested bits of universality in the shape of a woman — head — torso — feet — hands — Even some trees too. — just human trees — new ideas all."[14]

Stieglitz photographed O'Keeffe's hands with as much interest as he photographed her face. In doing so he suggested both his own intimacy with her touch, and the sensuality at the source of her painting. Rarely stooping to the literal description of brush in hand, he nevertheless made explicit the connection between her hands and her work (pages 32 and 33). In his photographs of O'Keeffe in front of her paintings, she gestures as if to conjure her imagery from a cosmic brew of body and mind (page 31). Everything she touched, Stieglitz seemed to be saying, even the air around her, was charged with fresh significance. She holds an apple branch as if it is a clarinet she is about to play, and strokes a horse's skull as if she could call it back to life (pages 132 and 114). Returning to the methods of his early family portraits, Stieglitz also pictured her with the attributes of domesticity. Her hands at work at the everyday activities of the house range from the practical, peeling apples, to the sublime, stitching cloth.

Through the experience of her touch, Stieglitz began to employ the full battery of his senses toward the making of photographs. Sharpening his focus he moved in on the bark of a tree (page 61), the flank of a horse (page 100), the weathered siding of a barn (pages 71 and 134), the raindrops on an apple branch (page 62). In full sunlight he embraced the texture — the skin — of his subject matter for the first time.

Before O'Keeffe's arrival, Stieglitz had dealt with nature only in terms of its remote atmospheric effects. His great respect for the scientific accuracy of his medium, learned as a student at the Berlin Polytechnic in the 1880s, is evident in every view he made of the city at the start of his career: snow, rain, mist, smoke, and steam turned everyday scenes into triumphs of technical mastery. It was through a filter of weather conditions that Stieglitz gave his views of New York a human dimension, and through the city's realistic depiction that he achieved his ultimate goal — subjectivity. In 1894 he had declared publicly that foul weather and polluted air

were the only conditions suitable to making a "true" photograph. "Atmosphere," he wrote, "is the medium through which we see all things. In order, therefore, to see them in their true value on a photograph, as we do in Nature, atmosphere must be there. Atmosphere softens all lines; it graduates the transition from light to shade; it is essential to the reproduction of the sense of distance. . . . The sharp outlines which we Americans are so proud of as proof of great perfection in our art are *untrue* to Nature, and hence an abomination to the artist."[15]

By the 1920s, Stieglitz had completely changed his mind. With O'Keeffe at Lake George he waited impatiently for the "deep blue clarity" of late August days.[16] And in New York he photographed from their window high in the Shelton Hotel in full sunlight, chronicling the daily passage of the city's hard-edged shadows. "Georgia and I somehow don't seem to be part of New York — nor of anywhere," Stieglitz wrote to the writer Sherwood Anderson in 1925, "We live high up in the Shelton Hotel — for awhile — maybe all winter — the wind howls and shakes the huge steel frame — We feel as if we were out at mid-ocean — All is so quiet except the wind — and the trembling shaking hulk of steel in which we live — It's a wonderful place — ."[17] With the distance of a philosopher, Stieglitz by day photographed skyscrapers under construction, as if they were trees growing out of his control, enhancing or obscuring his view, and in the evening photographed the windows near and far, lit up like a constellation of stars.

O'Keeffe's revolutionary sense of space grew out of her life in the great plains of the midwest. At Lake George her impatience with clutter both outside and in, her selection of this branch or that mushroom, liberated Stieglitz once and for all from the conventional contours of his Victorian holiday retreat. His 1920 portrait of O'Keeffe in the apple orchard, standing by with her saw as the gardener Donald Davidson pruned the apple tree (page 131), is symbolic of this metamorphosis. With O'Keeffe's help, he literally pruned his vision, as he began to appreciate the landscape as abstract space, waiting to be cut to the shape of his feelings. Margaret Prosser, the Stieglitz cook at Lake George, looked on in wonder as the odd couple took off for long mountain walks and rows on the lake, and observed the changes taking place in his art. "He did wonderful street scenes, portraits, railroad tracks and all that before Georgia came. But after Georgia came he made the clouds, the moon, he even made lightning. He never photographed things like that before."[18]

In photographing O'Keeffe's work, as he did constantly, Stieglitz created a fusion of media — first charcoal and then paint, rendered in silver. Through this chemical marriage he laid claim to abstraction in his realist medium. In his photograph of her 1919 painting *Blue and Green Music*, a reversal of this kind occurs, as what appears in the painting to be a tree becomes something more like a cloud in the photograph. Notably, this fusion precedes Stieglitz's first series of cloud photographs, *Music — A Sequence of Ten Cloud Photographs*, by only a few months. In his earliest cloud studies, a thin strip of land at the base of the picture gives a human dimension to the sky (pages 38, 46, and 134). Eventually, he severed ties with the ground, and his cloud pictures

took off into the stratosphere. Rarely did he turn the final image in the way that it would have been seen from the ground. Horizontals become soaring verticals and diagonals, and the sun, when it appears, could just as easily be the moon.

As artists working side by side, O'Keeffe and Stieglitz traded places as often as they followed each other's lead. As O'Keeffe's pictures became increasingly realistic and grounded, Stieglitz's became increasingly abstract and ephemeral. And as she magnified nature, most notably in her large flower paintings beginning in 1924, he miniaturized it, by reducing the sky to a 4x5-inch rectangle. This easy trade-off of scale reflects their shared sense of nature as microcosmic, that all its patterns were of the same order and completely reversible in the pursuit of their own self-expressive ends. It also might be understood as a metaphor for their differences — she at the beginning of her career, he at the end of his. In totality the work that followed their union as lovers suggests an astonishing blend, all the more interesting because it was made in two very different mediums, at two very different stages of life, and because one artist was male, the other female. The effect of viewing their work together, as Stieglitz intended and as we now can again with this exhibition and book, is like a system of mirrors, through which we easily forget where we stand. While their shared subject matter is the most literal point of comparison, we eventually submit to the realization that there was no other subject matter but themselves.

Which was more important to Stieglitz — the woman or her art? If this seems a hazardous question, it is not one that O'Keeffe herself hesitated to answer. She volunteered late in life that "for me, [Stieglitz] was much more wonderful in his work than as a human being. I believe it was the work that kept me with him — though I loved him as a human being. I could see his strengths and weaknesses. I put up with what seemed to me a good deal of contradictory nonsense because of what seemed clear and bright and beautiful."[19] I would venture to say that for Stieglitz the opposite was true. While there is no doubt that he took great interest in O'Keeffe's painting, he did not always respond to it favorably. But there was nothing in her character that he would have described as contradictory nonsense. It was in the absolute consistency with which she lived and expressed herself, while remaining utterly mysterious, that he found inspiration. "O'Keeffe is a constant source of wonder to me," he wrote to Arthur Dove in 1918, at the peak of his discovery, "like Nature itself."[20]

1. Giovanni Pontiero, *Duse on Tour* (Manchester: Manchester University Press, 1982), p. 36.

2. Alfred Stieglitz (AS) to Anne Brigman, December 26, 1913; Yale Collection of American Literature, New Haven, Connecticut (YCAL).

3. Calvin Tompkins, *Paul Strand: Sixty Years of Photographs* (Millerton, N.Y.: Aperture, 1976), p. 25.

4. AS to Marie Rapp (Boursault), September 8, 1915; YCAL.

5. AS to Rapp, September 15, 1915; YCAL.

6. Anita Pollitzer, *A Woman on Paper: Georgia O'Keeffe* (New York: Simon & Schuster, 1988), p. 140.

7. AS to Rapp, September 3, 1916; YCAL.

8. AS to Strand, August 31, 1916; YCAL.

9. AS to Rapp, September 29, 1916; YCAL.

10. AS to Rapp, August 26, 1916; YCAL.

11. Pollitzer, p. 145.

12. AS to Arthur Dove, summer 1918; YCAL.

13. AS to Dove, August 15, 1918; YCAL.

14. AS to Brigman, December 24, 1919; YCAL.

15. Sarah Greenough and Juan Hamilton, *Alfred Stieglitz: Photographs and Writings* (Washington, D.C.: National Gallery of Art, 1983), p. 182.

16. AS to Dove, August 15, 1918; YCAL.

17. AS to Sherwood Anderson, December 9, 1925; YCAL.

18. Pollitzer, p. 172.

19. Georgia O'Keeffe, *Georgia O'Keeffe: A Portrait by Alfred Stieglitz* (New York: The Metropolitan Museum of Art, 1978), p. 17.

20. AS to Dove, August 15, 1918; YCAL.

We work and we work and feel foolish
for working, then work some more.
Georgia O'Keeffe, October–November 1920

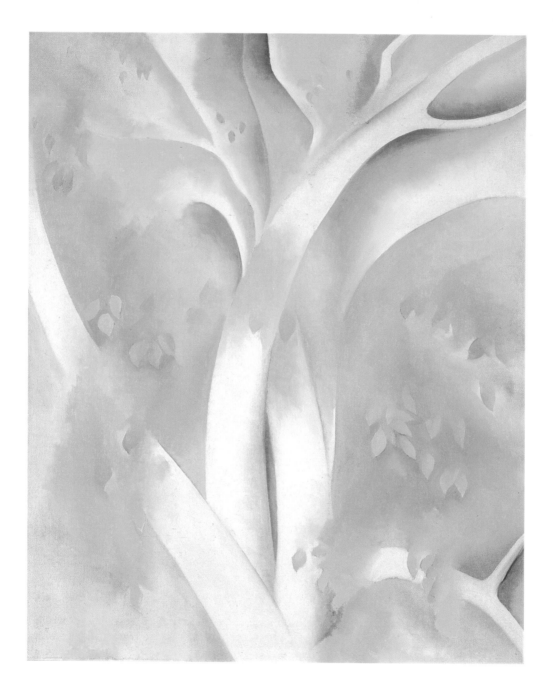

White Birch, 1925

Dancing Trees, 1922

Apple and Drops of Rain, 1922

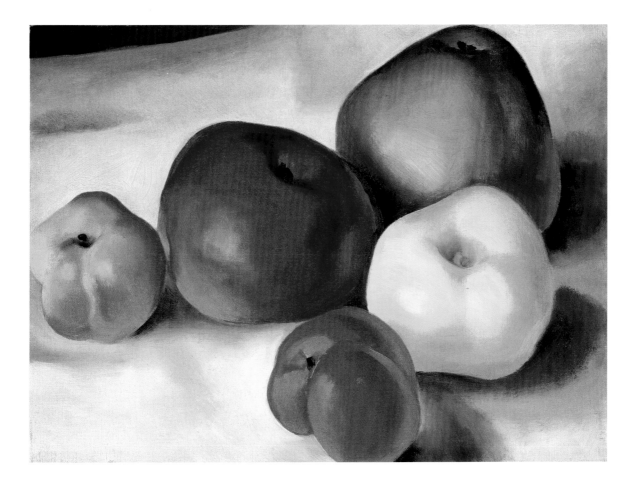

Apple Family III, c. 1921

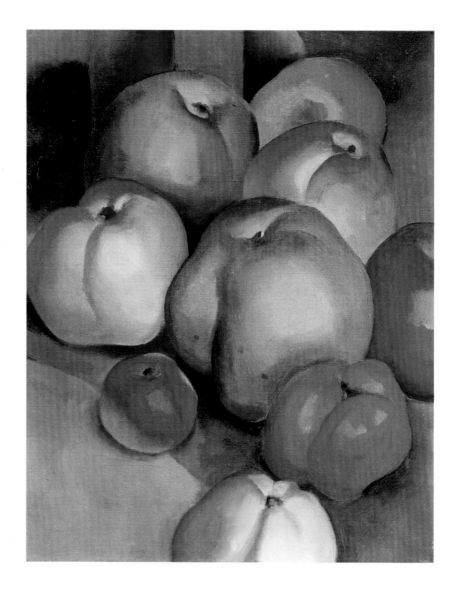

Apple Family A, 1921

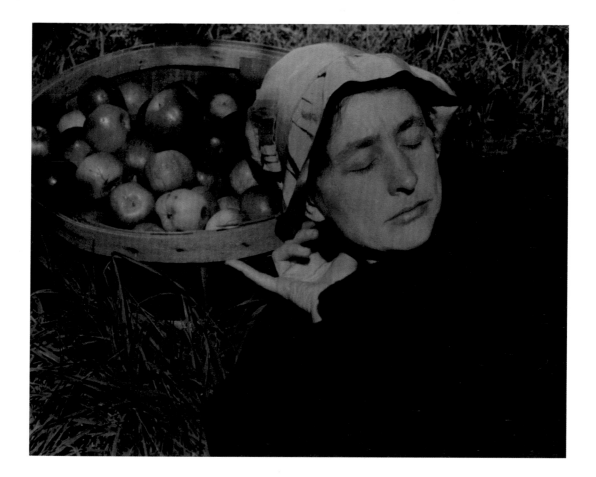

Georgia O'Keeffe: A Portrait, 1921

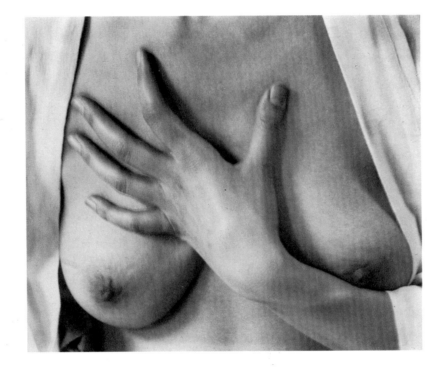

Georgia O'Keeffe: A Portrait, 1918–1919

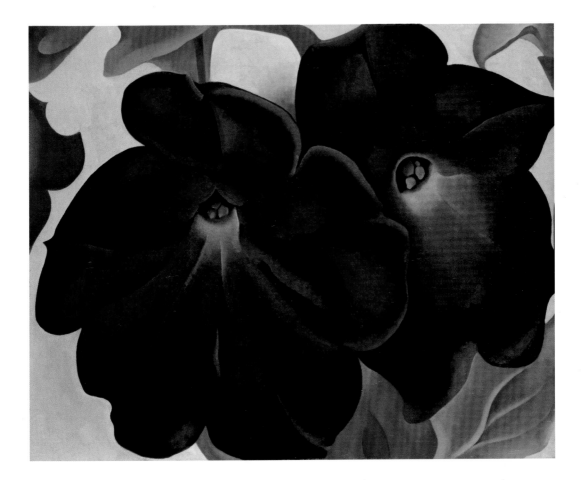

Black and Purple Petunias, 1925

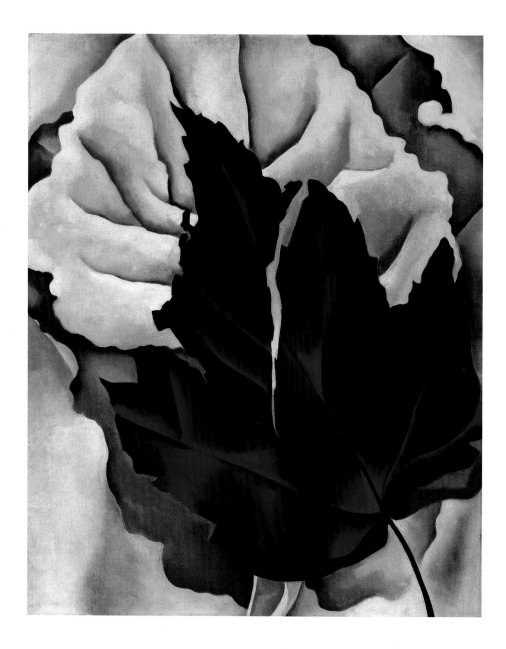

Pattern of Leaves, c. 1923

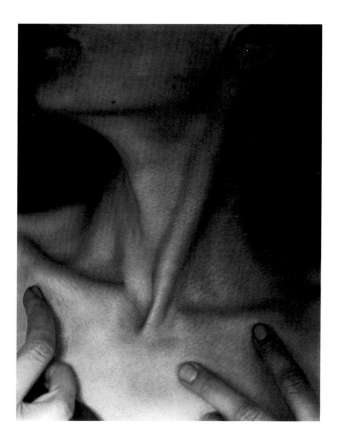

Georgia O'Keeffe: A Portrait – Neck, 1921

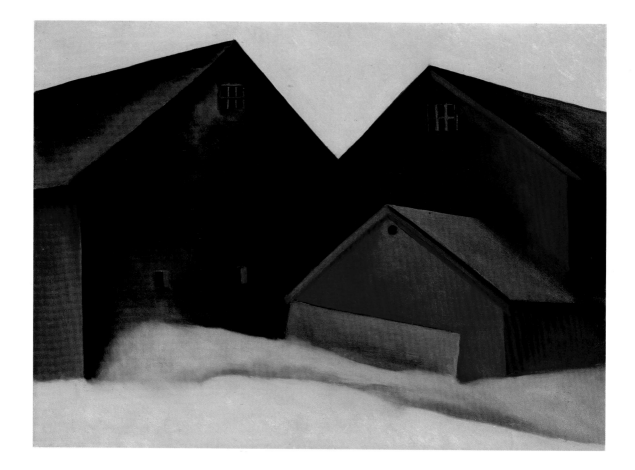

Ends of Barns, 1922

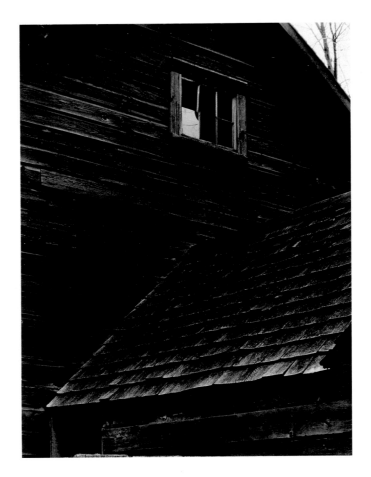

Lake George Barn, c. 1920

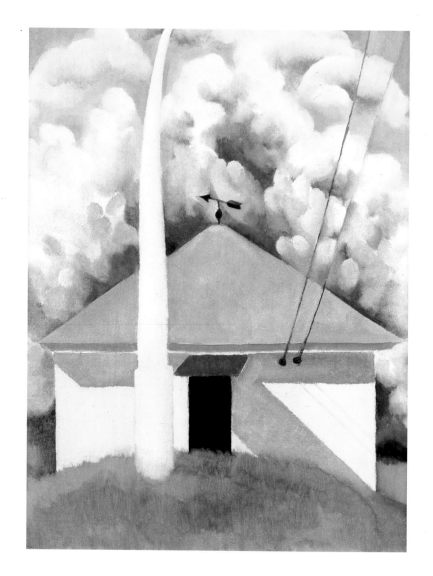

Spring, 1923

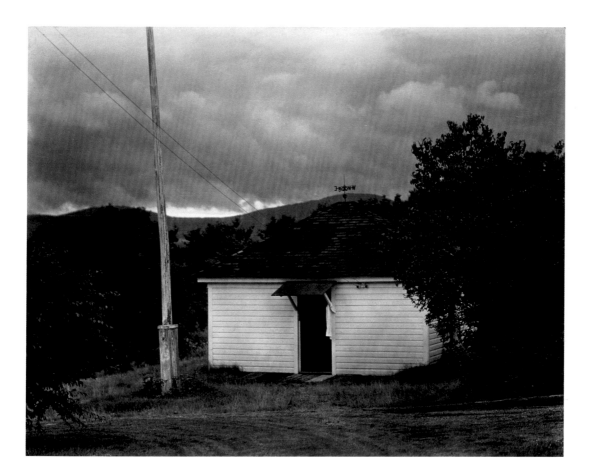

Little House, Lake George, 1930

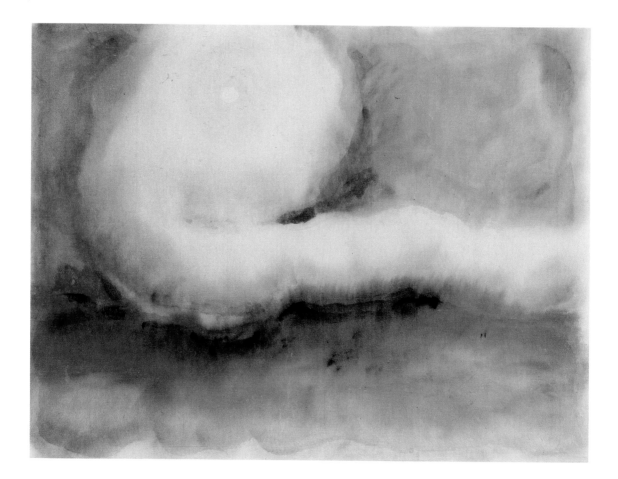

Evening Star, c. 1916

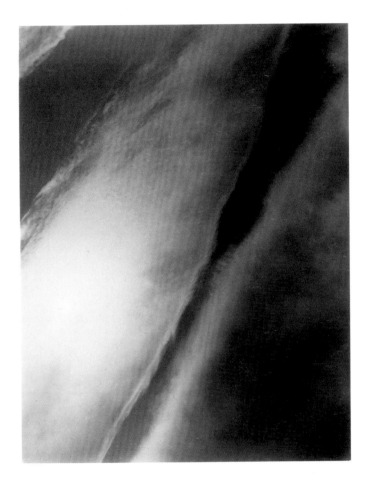

Equivalent, 1931

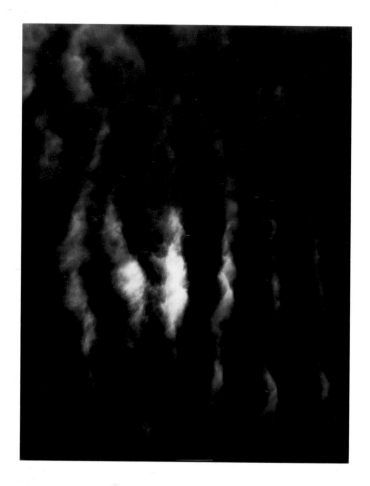

Equivalent, Set C, No. 5, 1929

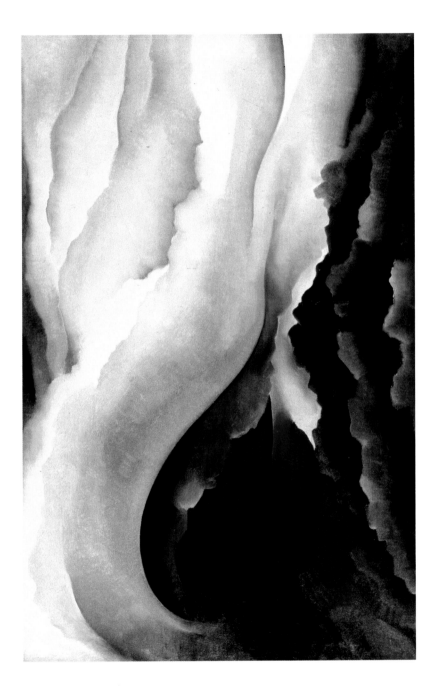

Dark Iris No. 2, 1927

"I CAN'T SING SO I PAINT"

ELIZABETH HUTTON TURNER

In the spring of 1924, Alfred Stieglitz organized the first and only joint exhibition of his photographs and Georgia O'Keeffe's paintings. O'Keeffe's contribution consisted of crisp renderings of trees and larger than life-size leaves, enough to fill the walls of a large room. Stieglitz was represented in two smaller spaces with a group of small spectral images of clouds. O'Keeffe's paint, thinly applied with no trace of a brush, appeared, according to one critic, "wished upon canvas."[1] By contrast, the Stieglitz photographs seemed almost painterly. One could imagine for a moment that the painter had changed places with the photographer. Whether inspired by the earth or the sky, Stieglitz and O'Keeffe shared the same intuition. Their images struck a common chord, which they attributed to nature and experience and characterized as "Music."

The possibility that art could be made to speak to the soul like music, without benefit of subject or narrative, had captivated American artists since Whistler. By the time of the 1913 Armory Show an entire generation of students, including O'Keeffe, had become acquainted with Arthur Wesley Dow's musically-inspired criticism of line and color. For those who met regularly at Stieglitz's gallery on Fifth Avenue, conversation centered on Vasili Kandinsky's newly published writings and colorful paintings. Stieglitz had even purchased for 291 the only Kandinsky painting displayed at the Armory Show. *Improvisation 27* remained at 291 after the show for young Americans like Marsden Hartley and Arthur Dove to use as a jumping-off place into artistic frontiers where rhythms of life and breath, pulse and inmost feeling could be made to live on canvas.

In the fall of 1915, sitting "at the tail end of the earth"[2] in Columbia, South Carolina, the young art teacher Georgia O'Keeffe embarked upon her second reading of Kandinsky's *Concerning the Spiritual in Art* and began to reflect on the expressive possibilities of a profoundly interior art. That spring, during her last visit to 291, she had come and gone without notice, seeing only bare walls and hearing "talk behind the curtain."[3] But

she liked the gallery all the same. Having painted no abstractions of her own, she was at this point quite invisible to the avant-garde, although in conversation she was using their vocabulary of art and musical metaphors. "Tell me — do you like my music"[4] was the question that accompanied the first tube of drawings O'Keeffe sent to her schoolmate Anita Pollitzer that summer.

In June O'Keeffe had left New York's Columbia University ready to try anything, to "bump her head against all hard walls."[5] She loved ragtime and Picasso no less than "the woods turning bright . . . and the pines singing."[6] Yet in late November, far from New York, the fall colors that had thrilled her in her work began to repel her. She had put away her brushes. Her professor, Arthur Wesley Dow, once a source of invention with his musical criticism of line and color, now seemed "disgustingly tame."[7] She looked enviously upon her ten-year-old student Adelaide, who was so easily delighted with her work. As though determined to shed the last vestiges of her academic skin, she resolved to forget her training and express herself directly with forms that would please her first — and then perhaps Stieglitz.

What happened that December came unexpectedly. Using a rudimentary charcoal stick on paper, O'Keeffe created a myriad of abstractions with grab-fisted movements of the whole arm. She drew wide swaths of gray, reaching tendrils, and waves that retreated in diagonals or deepened into rhythmic swirls. She found inspiration in the half-light of memory, imagination, and the gleam of the night sky. Her nightly vigil of star gazing, violin playing, and spontaneous drawing put into practice Kandinsky's suggestion that the painter literally apply the means of music to art. In so doing, O'Keeffe rediscovered childhood connections between art and music that she had abandoned when forced to choose between the two disciplines. By her own account, she played the violin until her fingers were sore and worked late into the night, crouched over her drawings on the studio floor. It felt foolish to try to make something as dull as charcoal sing with life. Yet O'Keeffe sensed something all her own reflected in the new images. Stieglitz agreed.

Anita Pollitzer's letter of January 1 arrived in Columbia, South Carolina like a late Christmas present. After acknowledging receipt of O'Keeffe's latest tube of drawings, Pollitzer assured her of the startling power the new works had to "shake the beast by the tail."[8] Her friend related how she had delivered the drawings to Stieglitz at 291 on New Year's Day and unrolled them in the twilight in front of the gray maestro, who looked long and hard before revealing his impressions. Like a palmist following the imprint of a hand, Stieglitz began to read character and intention into each line. "Why they're genuinely fine things — you say a woman did these — She's an unusual woman — She's broad minded, she's bigger than most women, but she's got the sensitive emotion. I'd know she was a woman — Look at that line."[9] Stieglitz was more accustomed to seeing the men of 291 struggle against conventional restraints, trying to infuse their abstractions with emotion. (He believed, as did other members of the avant-garde, that the real revolution in American culture would take place only when male-dominated American society accepted feminine qualities in art more whole-heartedly.) When Stieglitz

80

saw O'Keeffe's charcoals, he detected an artist who could do this with honesty and naturalness. At that moment, according to Pollitzer, he proclaimed O'Keeffe's drawings, "the purest, finest, sincerest things that have entered 291 in a long while — I wouldn't mind showing them in one of these rooms not one bit."[10]

O'Keeffe was only beginning to grasp what was emerging in the shallow fields of charcoal. The drawings themselves had the feel of a great, if tentative, experiment that she had difficulty in trusting. To continue, she would need more than Pollitzer's second-hand reports from 291. She was looking for a signal, some way of knowing whether her new abstractions had conveyed the necessary depth and resonance. A desire to enlist Stieglitz in that search can be clearly felt from the first request O'Keeffe wrote to 291. "If you remember for a week why you like my charcoals that Anita Pollitzer showed you and what they said to you — I would like to know if you want to tell me. . . . You probably know without my saying it that I ask because I wonder if I got over to anyone what I wanted to say."[11]

But O'Keeffe's daunting query evoked nothing definitive from Stieglitz, at least not immediately. Other than voicing his joy and surprise at discovering her work, Stieglitz offered little more than the hope of a future discussion. About her drawings he wrote, "I might give you what I received from them if you and I were to meet and talk about life."[12] O'Keeffe returned to New York that spring to complete her courses at Columbia, but she seems to have resisted the promised conversation about her drawings until later that June. It was Stieglitz who provoked their confrontation by exhibiting them without permission. He aptly described them as "songs of consciousness," although he mistakenly attributed them to a Miss "Virginia" O'Keeffe.[13] When O'Keeffe went to 291 to reclaim the drawings, Stieglitz provided his long overdue observations not with words but with the lens of his camera. A month later, the arrival in Charlottesville of nine photographs of her 291 exhibition assured and emboldened O'Keeffe. Like a painter-Narcissus falling in love with her own reflection, O'Keeffe wrote Pollitzer, "Isn't it funny that I hate my drawings — and am simply crazy about the photographs of them?"[14] What had attracted the painter to the photographs? Was it Stieglitz himself?

During the summer of 1916 O'Keeffe abandoned drawing with charcoal as though challenged by Stieglitz's photographs to try something bolder. She returned to color, to what, according to Kandinsky, was the starting point for spiritual exercise. In a series of blue watercolors O'Keeffe featured great arcs, shepherd's crooks, and enveloping spirals liberated from the labored handwriting of the charcoal drawings. The resulting coloristic chiaroscuro bore a striking resemblance to the photographer's tonal fields. By the time of her next letter to Stieglitz, O'Keeffe had cast aside the charcoals, like outmoded concerns. "I wouldn't mind if you wrote me that you had torn them all up — I don't want them — I don't want even to see them — but I'm not always the same — sometime I may have to tear them all up myself — You understand — they are all as much yours as mine. I don't care what you do with them as long as I don't have to see them."[15]

In the fall of 1916 O'Keeffe's most austere and accomplished watercolor abstraction hung near Stieglitz's office

door at 291. Much was read into two blue lines, the two nearly identical upward strokes of the Japanese brush, interrupted only by one that briefly fell away and another that pushed ahead in a widening wash. Anita Pollitzer's first glimpse of *Blue Lines X* (1916, page 4) in December 1916 left her thunderstruck and hungry for news from her friend. The ensuing letter hints at Pollitzer's awareness of the special relationship between Stieglitz and O'Keeffe that was fast overtaking her own. Pollitzer found in O'Keeffe's painting "two dependent on each other yet perfectly separate individual lines of fine dark blue."[16] Upon seeing her blue watercolor for the first time, the painter Arthur Dove was said to have praised O'Keeffe for "doing naturally what many of us fellows are trying to do, and failing."[17]

With mixed admiration and desire, Stieglitz had begun to pursue O'Keeffe's lead. In his photographs from the back window of 291, Stieglitz said he also wanted to capture something direct and intensely honest, "simplified in spite of endless detail."[18] A shared sense of solitude pervades descriptions of the night sky which they sent to one another. Stieglitz watches the lights gradually go out one by one in New York; O'Keeffe walks past silhouettes of the last house at sunset on the plains. Being alone was a new and particularly difficult challenge for Stieglitz as the activity and influence of his gallery diminished. By keeping her distance from New York and cultivating her singularity, O'Keeffe had become a model for him.

By the same token, Stieglitz's individualism inspired O'Keeffe. She compared the arrival of letters from 291 to drinking "fine cold water when you are terribly thirsty."[19] Early in the summer of 1916 she declared a proprietary interest in them to Pollitzer. "I would like you to read them but some way or other — they seem to be just mine."[20] There was indeed something private about the exchange which gave her a "curious keen kind of pleasure . . . [at] seeing the inside of him."[21] Such intimacy perhaps encouraged O'Keeffe to range freely and imaginatively among the back issues of *Camera Work* that fall before she made her own version of a Stieglitz photograph, in which she imposed images inspired by the plains upon the photographer's cityscapes.

Like other new themes, *Train at Night in the Desert* (1916, page 27) was probably developed in gouache before being painted in watercolor. In each version the head of a train and a plume of smoke are unmistakable and clearly allude to Stieglitz's *The Hand of Man* (1902, page 26). The expressive rhythms of billowing smoke reverberate on paper like the sound of a "train way off rumbling and humming,"[22] which haunted O'Keeffe in Canyon, Texas. Despite the ambiguities of her brush, or perhaps because of them, O'Keeffe's borrowing from the photographer demonstrates a growing sympathy with his ability to detect the underlying contours of visual reality. This had thus far eluded O'Keeffe in her watercolors. The homage she paid Stieglitz was only the recognition of a vague feeling that his photographs had made her see new colors. O'Keeffe needed to know more to adapt the aesthetics of photography in her painting, much as she had done already with music and the violin. Stieglitz would provide these lessons.

The last show to open at 291 was O'Keeffe's first solo exhibition. Her late arrival on June 4, 1917 became the

occasion for Stieglitz to rehang the show and to conduct a photo session with the painter. In the series of closely cropped views of her face and hands in front of *Blue I* (1917, pages 30 and 31), the photographer seemed to identify O'Keeffe literally with her own abstractions, likening certain gestures and forms on paper to those of the real woman. In one photograph, the blue watercolor loops about her head and shoulders, framing her features like the center of a flower. In another, her arms and hands trace the rounded perimeter of a watercolor as if ready to touch its spinning form, like a potter at the wheel. "Devoid of all mannerism, all formula,"[23] these pictures were a revelation to O'Keeffe. They seemed to lift a host of radiant angles and curves from the realm of familiarity. O'Keeffe showed them at once to her students in Texas. "Nothing like that," she later revealed, "had come into our world before."[24]

A year later in June 1918, soon after moving to New York, O'Keeffe, not her paintings, acted as model and muse. Stieglitz would come unprecedentedly close, stop down the lens, and let his eye range across her body. O'Keeffe would hold the poses for an inordinate, even physically uncomfortable period of time, submitting to the rigors of both the photographer and his slow glass negatives. There would be days at the 59th Street studio and at their Lake George retreat when O'Keeffe would rather work with Stieglitz at his photography than paint. Over time, she came to appreciate the quality of the deep black tones that were set off by white. She even compiled for her own use a portfolio from the photographs that Stieglitz threw away. Admiring photography, she soon would set off in a new direction in oils.

As early as 1919, those who saw the *Portrait* photo-series and O'Keeffe's abstractions together detected a connection. The photographer Paul Strand wrote to Stieglitz that "the grey painting and the portrait . . . seemed somehow related."[25] Dove also wondered if certain close-ups and O'Keeffe's paintings were not inhabited by the same abstract force.[26] It was true. Already during her first year with Stieglitz, O'Keeffe began exploring the photographer's shallow depth of field in which everything is visible. Her oil rendering of the sky-lit *59th Street Studio* describes an undulating architecture wavering between illusionistic depth and surface refraction. Radiant grays are etched with angular whites. The darkened doorway peels away like the upturned edges of a photograph floating in developing solution. Here O'Keeffe dispenses with the brushwork and perspective that usually accompany painterly bravura. Gone are the opacities of pure pigment and the accidental physical properties of medium that have captivated most modern painters. O'Keeffe's brush conveys crystalline tonalities with thinned-down oils, applied in controlled, anonymous strokes. Similarly, her *Music — Pink and Blue I* (1919, page 35) launches a great expanding arch whose open blue center seems to split the light into rivulets of red, orange, yellow, green, and blue that splash to the surface in wave-like succession. One might compare this imaginary vista of ridges and rills to Kandinsky's fiery hilltop cities, were it not for a graphic clarity that suggests something more immediate, and reminds one of the glistening skin against folds of a white kimono in Stieglitz's contemporary close-ups.

83

O'Keeffe discovered her own secret in the *Portrait* series. By dwelling on the particulars of fabric and flesh singled out by the photographer, O'Keeffe found another approach to painting. Stieglitz's photographs had made objects out of her abstractions. Her paintings had made abstractions out of his *Portrait* photographs. Now, sensitive to the subjective side of photography, O'Keeffe declared, "Nothing is less real than realism."[27] This realization freed her from the need to choose between abstraction and representation, art and photography. To both their ways of thinking it was an entirely new direction, one which put her and Stieglitz on an equal footing to pursue and capture "the real meaning of things" in nature together.

Over the course of the next four years both artists worked away from New York, following the rhythm of the seasons which peaked artistically in the fall with fifteen-hour days of painting and printing at Lake George. Away from the distractions of teaching and 291, they each focused on their art. O'Keeffe reported, "We work and we work and feel foolish for working, then work some more."[28] Each summer they would try "to learn the ABC of working"[29] all over again. Every year O'Keeffe would paint a kind of alphabet, consisting of apples, alligator pears, birches, cannas, and corn, as if ordering "unknowable things that lie so little below the surface of our matter-of-fact world."[30] Their letters convey a sense of living in a Walden-like outpost where each sunset harbored portents such as "the dark rainbow" and "the little grey cloud lying atop the mountain."[31] A simple tuft of grass along the roadside suggested to O'Keeffe a subject ripe for study, while Stieglitz looked for subtle patterns both in grape leaves and in O'Keeffe's hands. At the height of their shared researches, they actually photographed and painted on the same plot of ground. O'Keeffe's *My Shanty, Lake George* (1922, page 39) floats like a wise-eyed boat among the summer greens between the meadow and the "deep, deep purple and green almost black" line of hills.[32] In the same year Stieglitz used his *Songs of the Sky* series to praise the undulating movement of mountains against the gray firmament and catch the last gleam of twilight in the glint of a housetop set off by a dark hill.

In 1923, after her retrospective at the Anderson Galleries, O'Keeffe had grown impatient with critics who found in her works "painful and ecstatic climaxes" and "suppressed desires."[33] Attributing interpretations like these to the ambiguities that inevitably surrounded abstraction, O'Keeffe decided to change direction. Henceforth her work would be "on the ground . . . as objective as I can make it," she told the writer Sherwood Anderson.[34] That fall O'Keeffe was captivated by glimpses of landscape, such as that described in a letter to Stieglitz's niece Elizabeth. "A morning when everything is covered with frost — or light glistening ice — the still trembling moment before the sun comes and melts it all away."[35] She praised this quality in certain Stieglitz prints, and attempted to capture it herself in paint — in *Birch Trees at Dawn on Lake George* (1926, page 137), where the gold-orange mist hovers among the white limbs, or in *Leaf Motif*, where the tear in a red maple emits a warm yellow light that is set off by a frozen gray pattern of drier and thinner leaves. When O'Keeffe came back from the country she wanted another exhibition that would answer her critics.

By February, however, what had started out to be her own small exhibition became a dual showing of her paintings and Stieglitz's photographs. With Stieglitz now on board, O'Keeffe's battle with the critics would be waged with all the color and fire that the spirit of 291 could muster. As he had done before, Stieglitz provoked debate by republishing the previous year's reviews, both negative and positive, of O'Keeffe's abstractions. His portrayals of clouds and sky, representing literal abstractions found in nature, provided the perfect foil to O'Keeffe's vividly imagined, close-up renderings. They were sure to confound critics who questioned the merits of abstraction versus realism. But would the confusion of medium and aesthetics really clarify O'Keeffe in the minds of the critics? As the opening approached, O'Keeffe took to her bed, dreading the outcome, feeling defeated in advance.

O'Keeffe was only beginning to understand why. Just two years earlier she had confidently declared photography to be "part of her search." She maintained that she found music in Stieglitz's photographs whether viewed "right side up or upside down or sideways."[36] Yet now her winding explanation of the upcoming exhibition to Sherwood Anderson contradicted itself at every turn. "His is the continuation of a long fight," she wrote.[37] Hers was not. She wanted to confirm what she had started only last year. She agreed that Stieglitz had a case to prove, but it was one she personally had abandoned years ago. "He has done with the sky something similar to what I had done with color before — as he says, proving my case."[38] Stieglitz had embraced the painterly at the very moment when O'Keeffe felt most compelled to suppress it. Not even the provision of separate rooms or catalogues could keep this fact from surfacing and impinging upon the boldness of her new stance.

The question of ownership and territory colored the first and only exhibition of Stieglitz and O'Keeffe. The need to assert what was hers, and not his, gradually undermined their artistic collaboration and by the mid-1920s forced O'Keeffe into a direct confrontation with Stieglitz on a number of issues, from the use of blow-ups to the question of what subjects she should portray. After 1929, when O'Keeffe began to spend each summer in the southwest, Stieglitz was unable to influence her art. (He had, as O'Keeffe put it, given her "a present of myself."[39]) By 1930 O'Keeffe could state the issue succinctly. She told the editor of *New Masses*, Michael Gold, that every time she began a painting she asked the same question. "Before I put brush to canvas, I question, 'Is this mine? Is it all intrinsically of myself? Is it influenced by some idea or some photograph of an idea which I have acquired from some man?'"[40] Of course she knew the answer already, and had known since that fateful 1924 exhibition. Hers was a new architecture of color and form — of paint reborn by way of shedding outmoded concerns, first those of her teachers William Merritt Chase and Dow, and lastly, Stieglitz. O'Keeffe's search for pure expression led her to believe, like Kandinsky, that the medium of paint was less than perfect. This fundamental discontent, which spawned her remarkable power of invention, also influenced the way she tested her art against other standards. As she once said, "Singing has always seemed to me the most perfect means of expression. It is so spontaneous. And after singing, I think the violin. Since I cannot sing, I paint."[41]

1. Anonymous critic; see Charles C. Eldredge, *Georgia O'Keeffe* (New York: Abrams, 1991), p. 59.

2. Georgia O'Keeffe (GOK) to Anita Pollitzer (AP), December 1915; see Clive Giboire, ed., *Lovingly, Georgia: The Complete Correspondence of Georgia O'Keeffe and Anita Pollitzer* (New York: Simon & Schuster, 1990), p. 58. Unless otherwise noted, all correspondence between O'Keeffe and Pollitzer has been quoted from this volume and will be cited by page number only.

3. GOK to AP, June 1915, p. 6.

4. GOK to AP, June 1915, p. 5.

5. GOK to AP, August 25, 1915, p. 14.

6. GOK to AP, October 1915, p. 59.

7. GOK to AP, October 1915, p. 58.

8. AP to GOK, December 27, 1915, p. 109. O'Keeffe and Pollitzer's letters from this time refer frequently to a poem entitled *Tail of the World*. In order to change the world, creative individuals have to lay hold of something and "pull till they're dead."

9. AP to GOK, January 1, 1916, pp. 115–116.

10. AP to GOK, January 1, 1916, p. 116.

11. GOK to Alfred Stieglitz (AS), January 1916; see Anita Pollitzer, *A Woman on Paper: Georgia O'Keeffe* (New York: Simon & Schuster, 1988), pp. 123–124, and Roxana Robinson, *Georgia O'Keeffe* (New York: Harper & Row, 1989), p. 131.

12. AS to GOK, January 1916; see Pollitzer, p. 124 and Robinson, p. 131.

13. See Alfred Stieglitz, "Georgia O'Keeffe — C. Duncan — Rene Lafferty," in *Camera Work*, no. 48 (October 1916), pp. 12–13.

14. GOK to AP, August 1916, p. 174.

15. GOK to AS, July 27, 1916; see Jack Cowart, Sarah Greenough, and Juan Hamilton, *Georgia O'Keeffe: Art and Letters* (Washington, D.C.: National Gallery of Art, 1987), p. 154.

16. AP to GOK, December 1916, p. 222.

17. See Dorothy Norman, *Alfred Stieglitz, An American Seer* (New York: Random House, 1973), p. 131.

18. AS to R. Child Bayley, November 1, 1916; see Sarah Greenough and Juan Hamilton, *Alfred Stieglitz: Photographs and Writings* (Washington, D.C.: National Gallery of Art, 1983), p. 201.

19. GOK to AP, July 1916, p. 164.

20. Ibid.

21. GOK to Arthur MacMahon, October 15, 1916; see Robinson, p. 167.

22. GOK to Elizabeth Stieglitz, January 1918; see Cowart, Greenough, and Hamilton, p. 167.

23. GOK, "To *MSS*, and its 33 Subscribers and Others Who Read and Don't Subscribe!" letter to the editor, *MSS*, no. 4 (December 1922), pp. 17–18.

24. GOK, *Georgia O'Keeffe: A Portrait by Alfred Stieglitz* (New York: The Metropolitan Museum of Art, 1978), p. 10.

25. Paul Strand to AS, March 20, 1919; see Sarah Whitaker Peters, *Becoming O'Keeffe: The Early Years* (New York: Abbeville, 1991), p. 227.

26. Arthur Dove to AS, September 16, 1919; ibid.

27. GOK, "I Can't Sing, So I Paint!" *New York Sun*, December 5, 1922, p. 22; see Barbara Buhler Lynes, *O'Keeffe, Stieglitz and the Critics, 1916–1929* (Ann Arbor, Michigan: UMI Research Press, 1989), p. 180.

28. GOK to Elizabeth Stieglitz Davidson, October–November 1920, Yale Collection of American Literature, New Haven, Connecticut (YCAL).

29. AS to Paul Rosenfeld, September 20, 1920; see Peters, p. 226.

30. Randolph Bourne, "Maeterlinck and the Unknown," in *New Republic* (November 21, 1914), p. 26; see Edward Abrahams, *The Lyrical Left: Randolph Bourne, Alfred Stieglitz and the Origins of Cultural Radicalism in America* (Charlottesville: University Press of Virginia, 1986), p. 44.

31. GOK to Elizabeth Stieglitz Davidson, November 24, 1923; YCAL.

32. GOK to Elizabeth Stieglitz Davidson, October–November 1920; YCAL.

33. Paul Rosenfeld, "American Painting," in *Dial* (December 1, 1921), pp. 666–70; see Lynes, p. 171.

34. GOK to Sherwood Anderson, February 11, 1924; see Cowart, Greenough, and Hamilton, p. 176.

35. GOK to Elizabeth Stieglitz Davidson, November 24, 1923; YCAL.

36. GOK, "To *MSS*," pp. 17–18.

37. GOK to Sherwood Anderson, February 11, 1924; see Cowart, Greenough, and Hamilton, p. 176.

38. Ibid.

39. GOK to Dorothy Brett, early April 1930; see Cowart, Greenough, and Hamilton, p. 200.

40. See Lynes, p. 158.

41. GOK, "I Can't Sing, So I Paint!" p. 22; see Lynes, p. 180.

It is always such a struggle for me to leave him.

Georgia O'Keeffe, 1929

Georgia is always a different person when she is free —

with none of the ordinary responsibilities.

Alfred Stieglitz, 1929

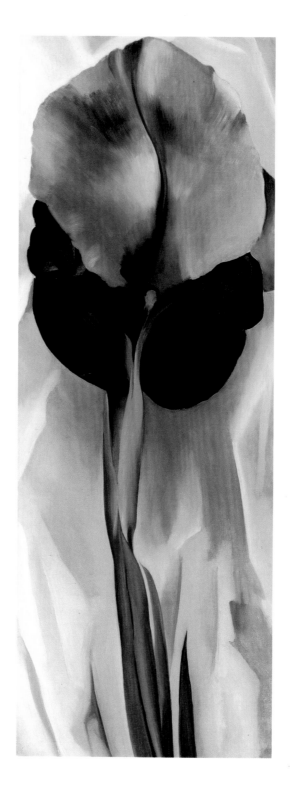

Iris [Dark Iris No. 1], 1927

Georgia O'Keeffe: A Portrait – Prospect Mountain, Lake George, 1927

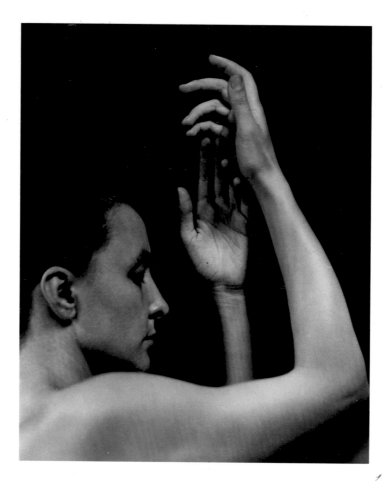

Georgia O'Keeffe: A Portrait – Profile, 1920

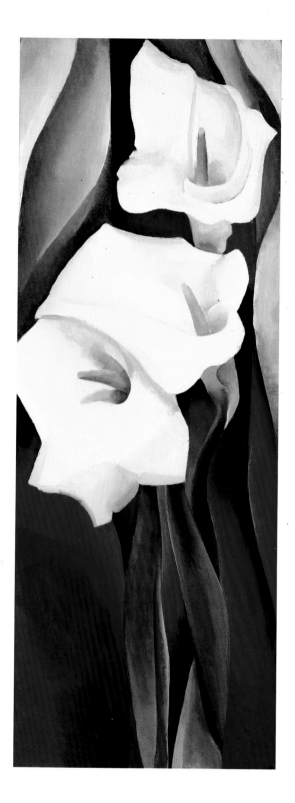

Calla Lilies, 1923

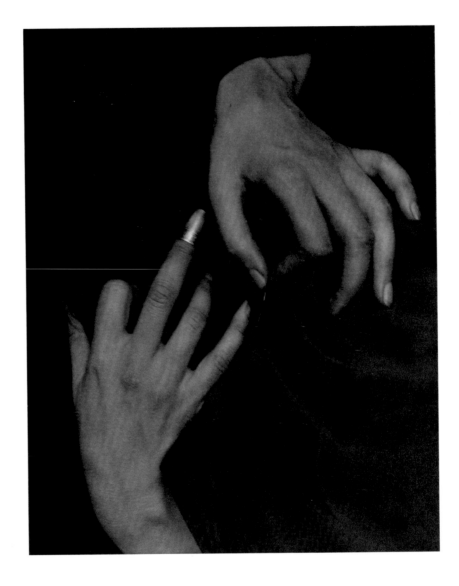

Hands and Thimble – Georgia O'Keeffe, 1920

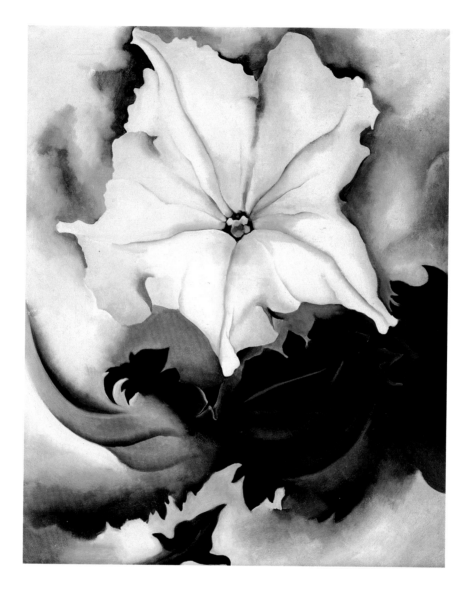

Petunia and Coleus, 1924

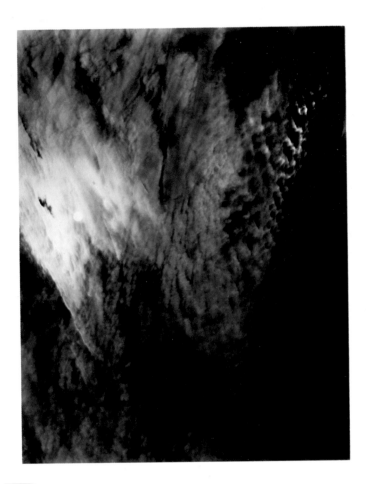

Equivalent, Series 20, No. 9, 1929

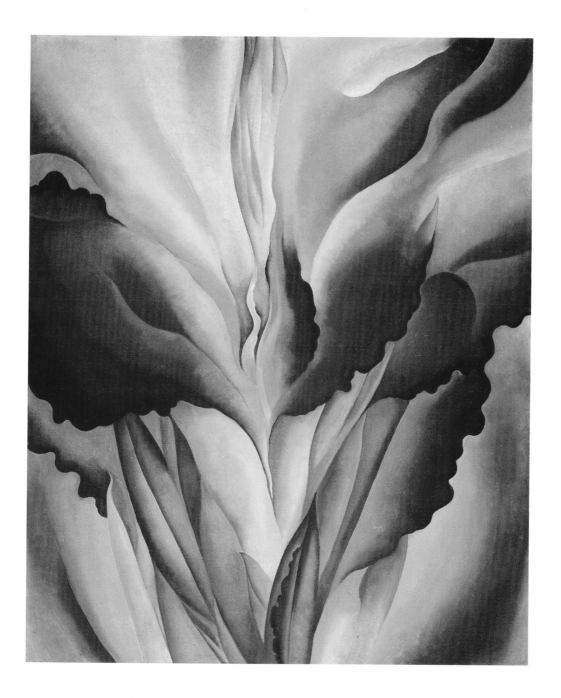

Red Canna, c. 1924

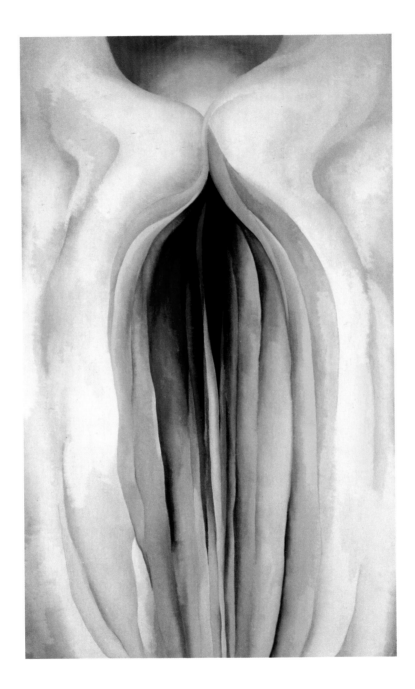

Grey Line with Black, Blue, and Yellow, c. 1923

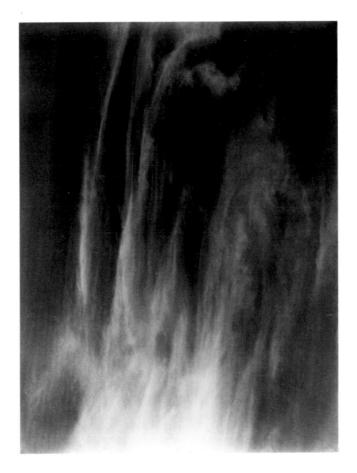

Equivalent, 1925

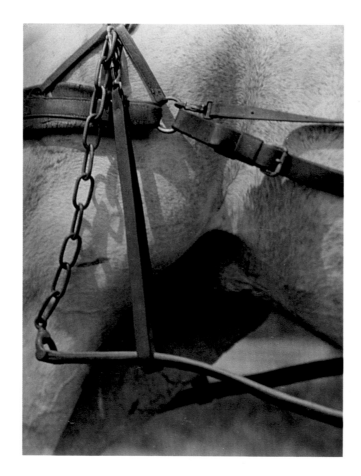

Spiritual America, 1923

White Abstraction (Madison Avenue), 1926

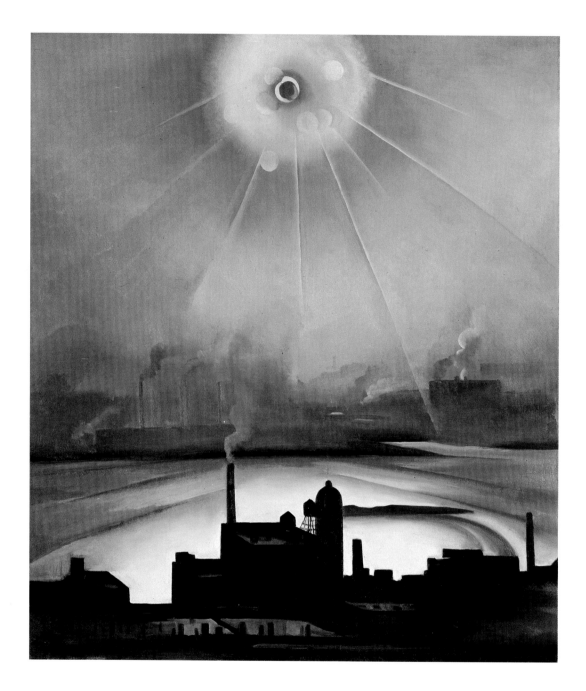

East River from the Shelton, 1927–28

From My Window at the Shelton – Southeast, 1931

104

The City of Ambition, 1910

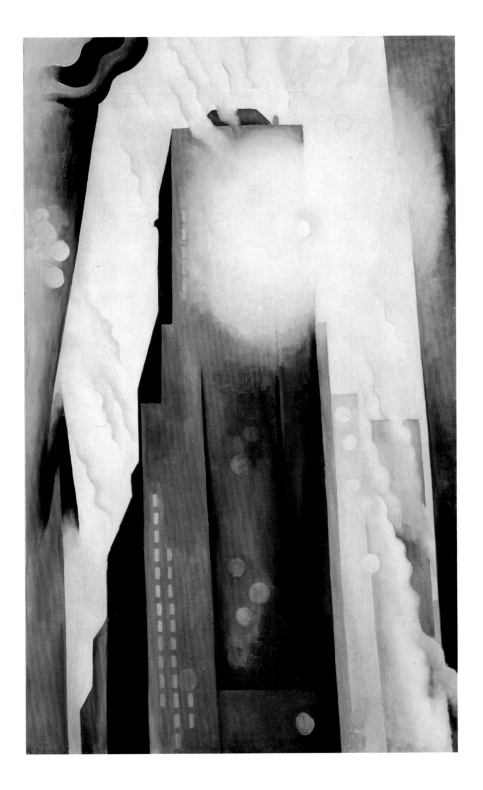

The Shelton with Sunspots, 1926

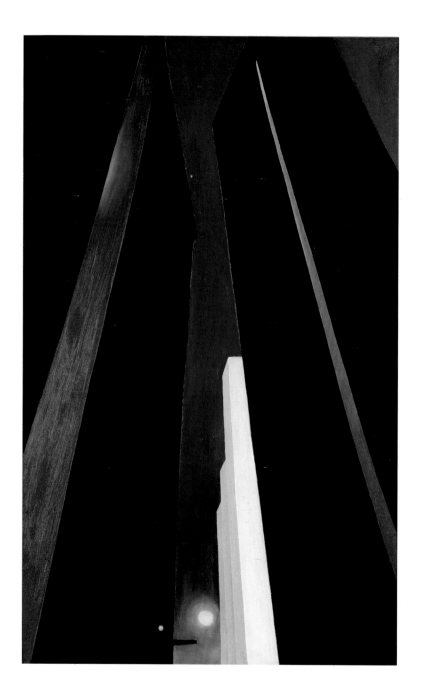

City Night, 1926

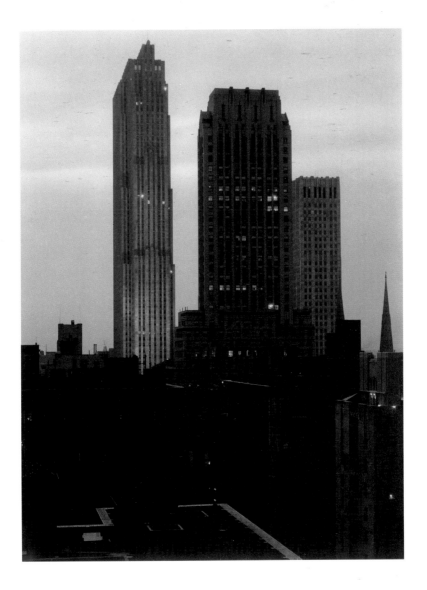

From the Shelton, Looking West, 1933

Georgia O'Keeffe: A Portrait – In Automobile, 1932–33

For me he was much more wonderful in his work than as a human being.

I believe it was the work that kept me with him. . . .

Georgia O'Keeffe, 1978

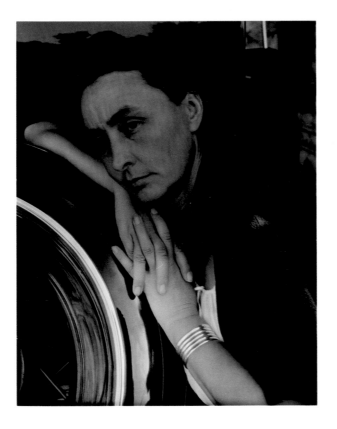

Georgia O'Keeffe, 1933

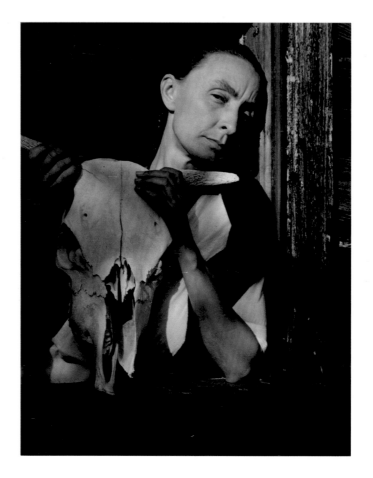

Georgia O'Keeffe: A Portrait – with Cow Skull, 1931

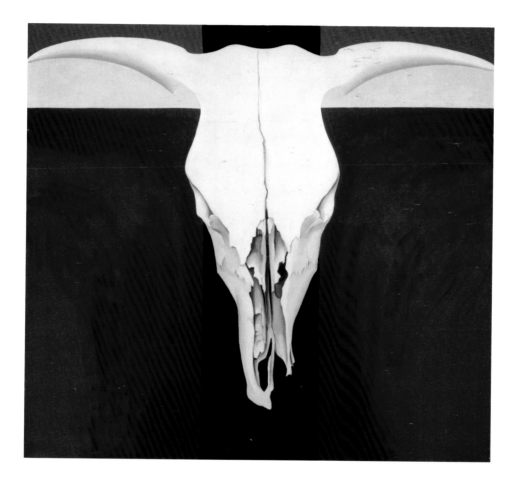

Cow's Skull on Red, 1931-36

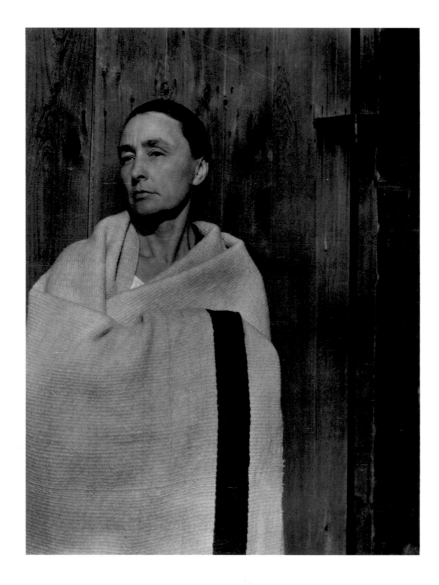

Georgia O'Keeffe: A Portrait, 1930

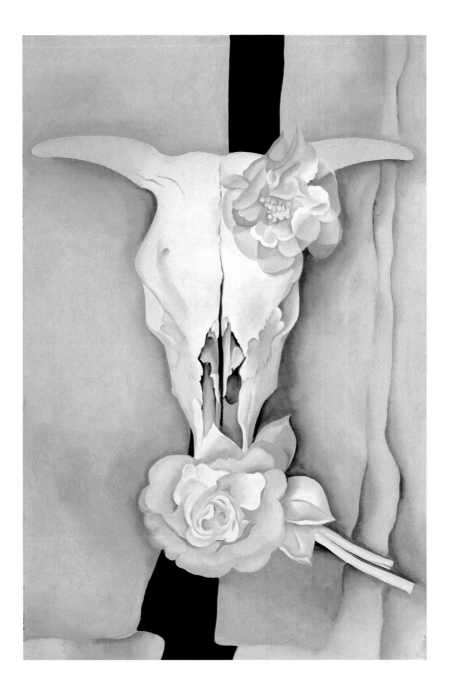

Cow's Skull with Calico Roses, 1932

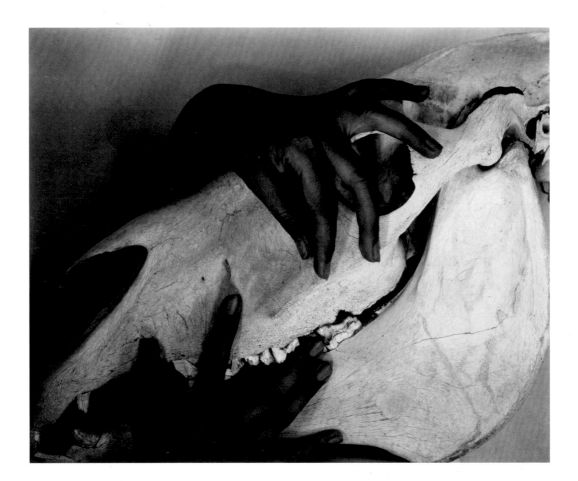

Georgia O'Keeffe, 1930

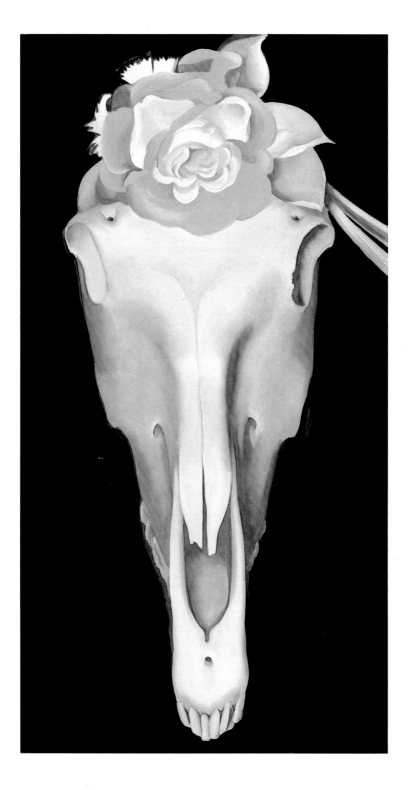

Horse's Skull with White Rose, 1931

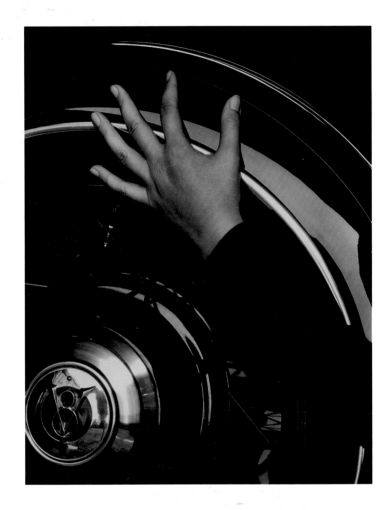

Hand and Wheel, 1933

Black and White, 1930

BIOGRAPHICAL HIGHLIGHTS

ELIZABETH V. CHEW

Although Alfred Stieglitz (b.1864) and Georgia O'Keeffe (b. 1887) did not encounter one another until 1908, their story begins in 1902, the year in which Stieglitz made his name in the New York art world and O'Keeffe's family moved east from Wisconsin to Virginia.

1902

April: Stieglitz mounts the first New York photography exhibition, *American Pictorial Photography*, at the National Arts Club. The group of photographers that he calls the Photo-Secession includes Edward Steichen, Anne W. Brigman, Gertrude Käsebier, Alvin Langdon Coburn, Clarence White, and Stieglitz himself. Through 1905 he organizes many Photo-Secession exhibitions in America and abroad.

December 15: First quarterly issue of *Camera Work*, Stieglitz's highly influential journal of photography and modernism.

1905

Spring: O'Keeffe graduates from Chatham Episcopal Institute, Chatham, Virginia.

Fall: O'Keeffe studies at The Art Institute of Chicago with John Vanderpoel, who taught in life classes the analogies between human anatomy, emotion, and the natural world, stressing the lyricism of line in the creation of volume.

November 24: Stieglitz and Steichen open The Little Galleries of the Photo-Secession at 291 Fifth Avenue (later known simply as "291"), with Stieglitz as director.

1906

Summer–Fall: O'Keeffe, ill with typhoid fever, leaves Chicago to recuperate with her family in Williamsburg. Remains at home until fall of 1907.

1907

January: An exhibition of drawings by Pamela Colman Smith is the first non-photographic show at 291.

September: O'Keeffe begins studies at the Art Students League in New York.

1908

January 2: O'Keeffe visits 291 with fellow students and teachers to see Stieglitz's exhibition of Rodin drawings, one of the first introductions New York received to the European avant-garde. This is her first encounter with him. It is the day after his forty-fourth birthday, and she is twenty.

April: O'Keeffe visits an exhibition of works on paper by Matisse at 291.

Fall: O'Keeffe returns to Chicago, working as a commercial illustrator through 1909.

December 1: The Little Galleries of the Photo-Secession moves to 293 Fifth Avenue, but continues to be known as 291.

1909

March 30: The painter John Marin has his American debut at 291.

Late in year: O'Keeffe returns to Virginia and moves to Charlottesville with her mother and four sisters.

1911

Spring: O'Keeffe teaches art at Chatham Episcopal Institute for six weeks. Stieglitz holds Picasso and Cézanne shows at 291.

1912

Publication of Vasili Kandinsky's *Über das Geistige in der Kunst (Concerning the Spiritual in Art)* in Munich. Stieglitz reads this enormously influential text and reprints a selection in the July issue of *Camera Work.*

Summer: O'Keeffe studies with Alon Bement at the University of Virginia in Charlottesville. He introduces her to the ideas of Arthur Wesley Dow, head of the art department at Columbia Teachers College in New York.

Fall: O'Keeffe works as art supervisor and teacher at public schools in Amarillo, Texas for two years.

1913

February 17 – March 15: The *International Exhibition of Modern Art* held at the Sixty-Ninth Regiment Armory in New York.

February 24 – March 13: Stieglitz holds the only solo show of his own works at 291 concurrently with the Armory Show. Thirty prints from 1892–1911 document his photographic evolution.

Summer: At Bement's invitation, O'Keeffe teaches drawing at University of Virginia summer school in Charlottesville. She returns to Amarillo in the fall.

1914

Publication of *Concerning the Spiritual in Art* in English.

Summer: O'Keeffe again teaching in Charlottesville.

Fall: Encouraged by Alon Bement to become a certified teacher, O'Keeffe goes to New York to enroll in Arthur Wesley Dow's classes. Befriends fellow student Anita Pollitzer, with whom she sees Braque/Picasso and Marin exhibitions at 291 that winter and spring.

1915

March: First issue of *291* edited by Marius De Zayas and financed by Stieglitz, Paul Haviland, and Agnes Meyer. The monthly publication continues until February 1916.

June: O'Keeffe's correspondence with Anita Pollitzer begins from Charlottesville, where she again teaches summer school. Stieglitz is alone at Lake George, beginning his retreat from the New York art world.

July: Pollitzer asks Stieglitz to send O'Keeffe the fourth issue of *291.*

August: O'Keeffe writes enthusiastically about *291* to Pollitzer, saying she has subscribed to it. Tells Pollitzer that she is trying to locate *Concerning the Spiritual in Art.*[1]

Fall: O'Keeffe takes a teaching post at Columbia College, a two-year Methodist women's college in Columbia, South Carolina.

October: O'Keeffe writes to Pollitzer, "I believe I would rather have Stieglitz like something — anything I had done — than anyone else I know of...."[2]

O'Keeffe begins to produce the highly original, abstract charcoal drawings which she calls *Specials.*

1916

January 1: Anita Pollitzer shows a group of O'Keeffe's charcoal drawings to Stieglitz and reports his favorable response to O'Keeffe. These include *Specials* 1–5 and 7–8, *Drawing 9,* and *Drawing 12,* all of 1915.[3] O'Keeffe writes to Stieglitz, "I make them just to express myself — things I feel and want to say — haven't words for."[4] Stieglitz responds: "They were a real surprise and above all I felt that they were a genuine expression of yourself."[5]

January 4: O'Keeffe writes to Pollitzer, "I can't begin to tell you how much I have enjoyed that *Camera Work....* That Picasso Drawing is wonderful music isn't it?"[6]

Late February: O'Keeffe accepts a job for the fall as head of the art department at West Texas State Normal College in Canyon. Leaves South Carolina and completes her courses with Dow at Columbia before moving west.

March: Paul Strand has his first exhibition at 291.

April: O'Keeffe sees a Marsden Hartley exhibition at 291.

May 23 – July 5: Stieglitz exhibits ten O'Keeffe charcoal drawings at 291 without her prior knowledge in a three-person show. O'Keeffe goes to 291 to demand that Stieglitz take the drawings down, but they remain on the walls.

May 2: Death of O'Keeffe's mother from tuberculosis in Charlottesville.

Summer: O'Keeffe in Charlottesville. She is corresponding with Stieglitz and tells Pollitzer, "Stieglitz sent me five wonderful *Camera Work*s — The Pictures excited me so that I felt like a human being for a couple of hours...."[7]

July 27: O'Keeffe writes to Stieglitz about her charcoals in the spring exhibition, "I seem to feel that they are as much yours as mine — They were only mine alone till the first person saw them...."[8]

August: O'Keeffe sends Stieglitz, in Lake George, a package of drawings from Charlottesville. He writes to his assistant Marie Rapp Boursault, "She is without doubt a girl much out of the ordinary."[9]

September: O'Keeffe takes over her post in Canyon, Texas. Writes to Pollitzer, "I'm so glad I'm out here — I can't tell you how much I like it. I like the plains — and I like the work — everything is so ridiculously new."[10]

November: O'Keeffe drawings included in a group show at 291.

O'Keeffe makes charcoals and watercolors including *Special 15, Train at Night in the Desert* (page 27), *Blue* series, *Sunrise and Little Clouds*.

1917

January: O'Keeffe writes to Pollitzer that she has been reading for a talk she is giving on aesthetics — "Wright, Bell, De Zayas, Eddy." (Willard Huntington Wright, *The Creative Will*, 1916; Clive Bell, *Art*, 1914; Marius De Zayas, *African Negro Art: Its Influences on Modern Art*, 1916; Arthur Jerome Eddy, *Cubists and Post-Impressionism*, 1914.)

April 3 – May 14: Solo O'Keeffe show at 291 features recent work in oil, watercolor, and charcoal. It is the last show at 291 before it closes in July.

May 25 – June 1: O'Keeffe comes to New York for ten days to see her exhibition which Stieglitz rehangs especially for her. Stieglitz photographs her for the first time. O'Keeffe meets Paul Strand.

June: O'Keeffe writes to Strand from the train on her way back to Texas that she is "making Strand photographs for myself in my head."[11] Travels to Colorado and to New Mexico for the first time. After returning to Texas, writes to Pollitzer about Strand, "He showed me lots and lots of prints.... And I almost lost my mind over them — Photographs that are as queer in shapes as Picasso drawings."[12]

June: Last issue of *Camera Work* is devoted entirely to Strand.

July 1: Closing of 291.

December: O'Keeffe has begun correspondence with Stieglitz's niece Elizabeth, the daughter of his brother Lee, whom she met in New York the previous summer. Writes to her, "Your letters are nice — no, nice isn't the word. They are wonderful — it would be great if you were here to talk to. Would you get up and leave these stupid maddening sort of folks ... — or would you stay and fight it out."[13]

O'Keeffe paints landscapes and abstractions in watercolor: *Light Coming On the Plains* series, *Evening Star* series.

1918

Early 1918: Stieglitz writes to photographer Anne Brigman, "I'm still daily at 291 — but am free. Have another tiny room now on the second floor — lots of light — & the fellows, Strand, Wright, Marin, Hartley, Walkowitz, Zoler, Marie [Rapp Boursault] (she's one of the "fellows") Dove, Bluemner, etc. gather there in all the tininess — The spirit has not changed an iota — my spirit — There are no exhibitions — but all the new work is brought to me — & much of it is magnificent."[14]

May: Stieglitz dispatches Paul Strand to Texas to check on O'Keeffe, who has been seriously ill with influenza, and to ask her to come to New York. This is a period of tremendous anxiety for Stieglitz, who is worried about her health and urgently desires her presence in the city. Stieglitz writes to Strand in Texas on May 17, "I want her to live — I never wanted anything as much as that — She is the spirit of 291."[15]

June 8: O'Keeffe arrives in New York, lives in Elizabeth's studio at 114 East 59th Street.

June 16: Stieglitz writes to Elizabeth, "The days in the studio have been the most wonderful I have ever experienced.... We have talked over practically everything — Into one week we have compressed years — I don't think there has ever been anything to equal it."[16]

July 8: Stieglitz moves into the 59th Street studio, separating from his wife Emmeline Obermeyer. Begins his series *Georgia O'Keeffe: A Portrait.*

August: O'Keeffe's first trip to Lake George. She writes to Elizabeth, "We are very happy here — was never so happy in my life."[17]

1919

April 27: Stieglitz writes to critic Sadakichi Hartmann, "I am at last photographing again — just to satisfy something within me — & all who have seen the work say that it is a revelation. — It is straight. No tricks of any kind.... It is so sharp that you can see the [pores] in a face — & yet it is abstract.... It is a series of about 100 pictures of one person — heads & ears — toes — hands — torsos — . It is the doing of something I have had in mind for very many years."[18]

Fall: 291 Fifth Avenue demolished.

O'Keeffe paints *Orange and Red Streak* (page 36), *Music — Pink and Blue* (pages 35 and 131), *Blue and Green Music.*

1920

Late Summer: Stieglitz and O'Keeffe renovate a shanty on the Lake George property for O'Keeffe to use as a studio. O'Keeffe will paint *My Shanty, Lake George* (page 39) in 1922.

Fall: O'Keeffe begins a series of still lifes of fruit. Stieglitz writes to Marie Rapp Boursault, "Georgia is painting apples [pages 63 and 64]. She has the apple fever."[19] They remain at Lake George through the fall.

December: Stieglitz and O'Keeffe move to his brother Lee's house at 60 East 65th Street.

1921

February: Forty-five Stieglitz photos of O'Keeffe taken since 1917 exhibited at Anderson Galleries in a retrospective of 145 prints. This is his first show since 1913.

O'Keeffe paints *Lake George with Crows* (page 42), abstracted Lake George landscapes, and apple paintings.

1922

Summer–Fall: Stieglitz begins to photograph clouds. Publishes *How I Came to Photograph Clouds* in 1923: "I

wanted to ... find out what I had learned in forty years about photography. Through clouds to put down my philosophy of life.... So I began to work with the clouds — and it was great excitement — daily for weeks."[20]

Stieglitz converts a greenhouse on the Lake George property into a darkroom. This will be referred to by both as "The Little House."

O'Keeffe creates more Lake George landscapes and first leaf paintings.

1923

January 29 – February 10: Large O'Keeffe show of one hundred works organized by Stieglitz at Anderson Galleries. Of these works, ninety have never shown publicly before.

April 2 – April 16: Stieglitz has a one man show of 116 works at Anderson Galleries, including cloud photographs.

O'Keeffe paints leaves and first calla lilies.

1924

March 3–16: Simultaneous exhibition of fifty-one O'Keeffe paintings and sixty-one Stieglitz photographs at Anderson Galleries. O'Keeffe's work is shown in one room, Stieglitz's in two adjacent ones.

September 9: Stieglitz is divorced from Emmeline Obermeyer.

December 11: Stieglitz and O'Keeffe are married by a Justice of the Peace in Cliffside Park, New Jersey, with John Marin as witness.

1925

March: *Seven Americans* show at Anderson Galleries, organized by Stieglitz, includes work by himself, O'Keeffe, Marin, Hartley, Dove, Demuth, and Strand. O'Keeffe exhibits first large format flower paintings, begun the previous year.

November: Stieglitz and O'Keeffe move to Suite 3003 of the Shelton Hotel (Lexington Avenue between 48th and 49th).

December 7: Stieglitz opens The Intimate Gallery in the Anderson Galleries Building, Room 303, with a Marin exhibition. Dorothy Norman, who will have increasingly close ties with Stieglitz over the next five years, begins to visit the gallery.

O'Keeffe creates first skyscraper painting, *New York with Moon.*

1926

January 11 – February 7: During a visit to the Arthur Dove exhibition at The Intimate Gallery, Duncan and Marjorie Phillips see work by O'Keeffe. Stieglitz writes to the Phillipses after the visit, "Please remember I am not in the art business. I am not eager to sell anything to anybody but I have a perfect passion in wishing to be instrumental in bringing out the best that is in America and bringing those who believe in that and are willing to work for that together."[21]

1926–1929

Annual O'Keeffe exhibitions at The Intimate Gallery.

1927

June–September: Small O'Keeffe retrospective takes place at The Brooklyn Museum.

1928

September: Stieglitz has first severe angina attack.

1929

Spring: Having grown weary of the New York and Lake George cycle and hungering for a change, O'Keeffe decides to accept the invitation of Mabel Dodge Luhan to visit New Mexico. She writes to critic Blanche Matthias, "It is always such a struggle for me to leave [Stieglitz]."[22]

April 27: O'Keeffe goes to New Mexico with Paul Strand's wife, Rebecca, for four months, staying with Luhan in Taos.

June: The Intimate Gallery closes. In December an exhibition of works by Marin inaugurates Stieglitz's new gallery, An American Place, 509 Madison Avenue.

September: O'Keeffe returns from New Mexico. Writes to Luhan from Lake George, "It is wonderful to be here and be with my funny little Stieglitz."[23]

November: Five O'Keeffe paintings are included in second exhibition at the new Museum of Modern Art.

O'Keeffe paints *Lake George Window* (page 41), *New York, Night,* and *At the Rodeo.*

1930

June 17 – September 5: O'Keeffe in New Mexico, staying with Luhan in Taos.

1930–1946

Annual O'Keeffe shows at An American Place.

1931

April–July: O'Keeffe in New Mexico.

July: Stieglitz visits Wood's Hole, Massachusetts to be with Dorothy Norman.

1932

February–March: Solo Stieglitz show at An American Place, his first since 1924. 127 prints, 1892–1932, including his small New York shots of the 1890s and the *From the Shelton* series (pages 103, 107, 141).

1934

June–September: O'Keeffe in New Mexico, staying at Ghost Ranch, a dude ranch twelve miles north of Abiquiu.

December: Stieglitz's last solo exhibition is held at An American Place, sixty-nine prints, 1884–1934.

1936

Summer: O'Keeffe at Ghost Ranch.

October: Stieglitz and O'Keeffe move to 405 East 54th Street.

1937

October 27 – December 27: Both Stieglitz and O'Keeffe included in large group show *Beginnings and Landmarks, "291," 1905–1917,* at An American Place.

Winter: Stieglitz stops photographing.

1938

April: Stieglitz has a heart attack followed by pneumonia.

Summer: O'Keeffe at Ghost Ranch.

1940

October: After spending the summer there, O'Keeffe buys her house at Ghost Ranch.

1941

October 17 – November 27: Group exhibition at An American Place includes work by both Stieglitz and O'Keeffe.

1942

October: Stieglitz and O'Keeffe move to a smaller apartment at 59 East 54th Street.

The Museum of Modern Art exhibits its Stieglitz photographs, acquired the previous year.

1943

Large O'Keeffe retrospective at The Art Institute of Chicago.

1944

July 1 – November 1: Stieglitz's collection of paintings and photographs shown at Philadelphia Museum of Art.

1945

O'Keeffe buys abandoned house in Abiquiu, New Mexico and spends next three years remodeling.

1946

May 14 – August 25: O'Keeffe retrospective at The Museum of Modern Art.

June 5: O'Keeffe goes to New Mexico.

July 12: O'Keeffe receives a telegram reporting that Stieglitz has suffered a massive stroke, flies to New York.

July 13: Stieglitz dies.

1946–1949

O'Keeffe, with the assistance of Doris Bry, organizes and disperses Stieglitz's large art collection, which includes his own photographs.

In 1949, at the age of sixty-one, O'Keeffe moves permanently to New Mexico, living in Abiquiu in the winter and spring and at Ghost Ranch in the summer and fall. She continues to work for most of the next thirty years. A retrospective organized by Lloyd Goodrich for the Whitney Museum of American Art in 1970 travels to Chicago and San Francisco. In 1973 O'Keeffe meets Juan Hamilton, who becomes her assistant and companion. The 1976 publication of *Georgia O'Keeffe* by Viking Press, with text by O'Keeffe, sets high standards for the reproduction of her work. In 1978 she contributes an introduction to *Georgia O'Keeffe: A Portrait by Alfred Stieglitz*, the catalogue for an exhibition at The Metropolitan Museum of Art of fifty-one photographs of herself from 1917–1933. She dies on March 6, 1986 in Santa Fe, eight months before her ninety-ninth birthday.

1. See Clive Giboire, ed., *Lovingly, Georgia: The Complete Correspondence of Georgia O'Keeffe and Anita Pollitzer* (New York: Simon & Schuster, 1990), pp. 9–17. Except where noted, all correspondence between O'Keeffe (GOK) and Pollitzer (AP) has been quoted from this volume and will be cited by page number only.

2. GOK to AP, October 1915, p. 40.

3. See Sarah Whitaker Peters, *Becoming O'Keeffe: The Early Years* (New York: Abbeville, 1991), p. 37 ff.

4. GOK to Alfred Stieglitz (AS), January 1916; see Roxana Robinson, *Georgia O'Keeffe* (New York: Harper & Row, 1989), p. 131.

5. AS to GOK; see Robinson, pp. 131–132.

6. GOK to AP, January 4, 1916; see Peters, p. 81. The edition of *Camera Work* was the special number of August 1912. The Picasso referred to is the Nude of 1910, now in The Metropolitan Museum of Art, New York.

7. GOK to AP, June 1916; see Giboire, ed., p. 159.

8. GOK to AS, July 27, 1916; see Jack Cowart, Sarah Greenough, and Juan Hamilton, *Georgia O'Keeffe: Art and Letters* (Washington, D.C.: National Gallery of Art, 1987), p. 154. Hereafter referred to as A&L.

9. AS to Marie Rapp Boursault (MRB), August 26, 1916; Yale Collection of American Literature, New Haven, Connecticut (YCAL).

10. GOK to AP, September 1916, p. 187.

11. GOK to Paul Strand (PS), June 3, 1917; A&L, p. 161.

12. GOK to AP, June 20, 1917, p. 256.

13. GOK to Elizabeth Stieglitz Davidson (ESD), late December 1917 or January 1918; A&L, p. 166.

14. AS to Anne Brigman, c. January 1918; YCAL.

15. AS to PS, May 17, 1918; see Benita Eisler, *O'Keeffe & Stieglitz: An American Romance* (New York: Doubleday, 1991), p. 169.

16. AS to ESD, June 16, 1918; YCAL.

17. GOK to ESD, August 15, 1918; YCAL.

18. AS to Sadakichi Hartmann; see Sarah Greenough and Juan Hamilton, *Alfred Stieglitz: Photographs and Writings* (Washington, D.C.: National Gallery of Art, 1983), p. 205.

19. AS to MRB, October 6, 1920; YCAL.

20. Quoted in Greenough and Hamilton, p. 207.

21. AS to Duncan Phillips, March 9, 1926; The Phillips Collection Archives, Washington, D.C.

22. GOK to Blanche Matthias, April 1929; see Robinson, p. 319.

23. GOK to Mabel Dodge Luhan, September 1929; see A&L, p. 196.

VISUAL CHRONOLOGY

1901–1910

Alfred Stieglitz: *Spring Showers*, 1901
Photogravure, 12 x 5 in (30.5 x 12.7 cm)
Collection of Michael and Ginny Abrams. Photograph by Lee Stalsworth.

Alfred Stieglitz: *The Hand of Man*, 1902
Photogravure, 9 ½ x 12 ⁹⁄₁₆ in (24.1 x 31.9 cm)
Collection of The Museum of Modern Art, New York. Purchase.
Reproduction page 26.

Alfred Stieglitz: *The Steerage*, 1907
Photogravure, 12 ½ x 10 in (31.8 x 25.4 cm)
Private Collection.
Reproduction page 28.

Alfred Stieglitz: *The Aeroplane*, 1910
Photogravure, 5 ¹¹⁄₁₆ x 6 ⅞ in (14.4 x 17.5 cm)
Sandra Berler, Dealer, Fine Photographs. Photograph by Lee Stalsworth.

Alfred Stieglitz: *The City of Ambition,* 1910
Photogravure, 13⅜ x 10½ in (34 x 26.7 cm)
Collection of The Museum of Modern Art, New York. Purchase.
Reproduction page 104.

1915

Georgia O'Keeffe: *Special No. 5*
Charcoal on paper, 24 x 18½ in (61 x 47 cm)
Anonymous loan. Photograph © 1987 Malcolm Varon, New York.

Georgia O'Keeffe: *Special No. 9*
Charcoal on paper, 25 x 19 in (63.5 x 48.3 cm)
The Menil Collection, Houston. Photograph © 1987 Malcolm
Varon, New York.
Reproduction page 29.

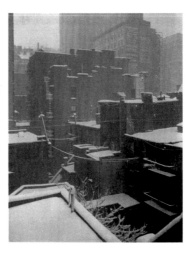

Alfred Stieglitz: *From the Window of "291"*
Platinum print, 9¹⁵⁄₁₆ x 7¹⁵⁄₁₆ in (25.2 x 20.2 cm)
Photograph © 1992 The Art Institute of Chicago, Alfred Stieglitz
Collection (1949.710). All rights reserved.

1916

Georgia O'Keeffe: *Abstraction IX*
Charcoal on paper, 24¼ x 18¾ in (61.6 x 47.6 cm)
The Metropolitan Museum of Art, Alfred Stieglitz Collection, 1969
(69.278.4). Photograph by Malcolm Varon.
Reproduction page 25.

Georgia O'Keeffe: *Blue Lines X*
Watercolor on paper, 25 x 19 in (63.5 x 48.3 cm)
The Metropolitan Museum of Art, Alfred Stieglitz Collection, 1969
(69.278.3). Photograph by Malcolm Varon.
Reproduction page 4.

Georgia O'Keeffe: *Evening Star,* c. 1916
Watercolor on paper, 13⅜ x 17¾ in (34 x 45.1 cm)
Yale University Art Gallery. The John Hill Morgan, B.A. 1893,
Fund, Leonard C. Hanna, Jr., B.A. 1913, Fund, and Gifts of
Friends in honor of Theodore E. Stebbins, Jr., B.A. 1960.
Photograph by Joseph Szaszfai.
Not included in the exhibition.
Reproduction page 74.

Georgia O'Keeffe: *Train at Night in the Desert*

Watercolor with traces of pencil on paper, 12 x 8⅞ in

(30.5 x 22.5 cm)

Collection of The Museum of Modern Art, New York. Acquired with

matching funds from the Committee on Drawings and the National

Endowment for the Arts.

Reproduction page 27.

1917

Georgia O'Keeffe: *Blue I*

Watercolor on paper, 30¾ x 22⅜ in (78.1 x 56.8 cm)

Collection of Robert L. B. Tobin. Photograph by Steven Sloman.

Reproduction page 30.

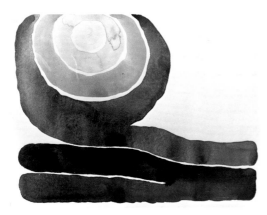

Georgia O'Keeffe: *Evening Star No. III*

Watercolor on paper, 9 x 11⅞ in (22.9 x 30.2 cm)

Collection of The Museum of Modern Art, New York. Mr. and Mrs.

Donald B. Strauss Fund.

Alfred Stieglitz: *Georgia O'Keeffe Exhibition at "291"*

Gelatin silver print, 6¼ x 9 in (15.9 x 22.9 cm)

Zabriskie Gallery, New York. Photograph by David M. Heald.

1918

Alfred Stieglitz: *Georgia O'Keeffe: A Portrait*

Gelatin silver print, 9⅝ x 7⅝ in (24.4 x 19.4 cm)

National Gallery of Art, Washington, Alfred Stieglitz Collection

(1980.70.73). Photograph by Dean Beasom.

Reproduction page 31.

Alfred Stieglitz: *Georgia O'Keeffe*

Platinum print, 9¹³⁄₁₆ x 7¹⁴⁄₁₆ in (24.9 x 20 cm)

Photograph © 1992 The Art Institute of Chicago, Alfred Stieglitz

Collection (1949.753). All rights reserved.

Alfred Stieglitz: *Georgia O'Keeffe: A Portrait — Hands*
Gelatin silver print, 4 7/16 x 3 7/16 in (11.3 x 8.7 cm)
National Gallery of Art, Washington, Alfred Stieglitz Collection
(1980.70.43). Photograph by Dean Beasom.
Reproduction page 32, bottom.

Alfred Stieglitz: *Georgia O'Keeffe: A Portrait — Hands and Face*
Gelatin silver print, 4 1/2 x 3 3/8 in (11.4 x 8.6 cm)
National Gallery of Art, Washington, Alfred Stieglitz Collection
(1980.70.50). Photograph by Philip A. Charles.
Reproduction page 33.

Alfred Stieglitz: *Georgia O'Keeffe: A Portrait — Head*
Gelatin silver print, 9 7/16 x 7 7/16 in (24 x 18.9 cm)
National Gallery of Art, Washington, Alfred Stieglitz Collection
(1980.70.23). Photograph by Dean Beasom.

1919

Alfred Stieglitz: *Georgia O'Keeffe: A Portrait*
Gelatin silver print, 4 5/8 x 3 1/2 in (11.7 x 8.9 cm)
National Gallery of Art, Washington, Alfred Stieglitz Collection
(1980.70.76). Photograph by Philip A. Charles.

Alfred Stieglitz: *Georgia O'Keeffe: A Portrait*, 1918–1919
Palladio print, 8 x 10 in (20.3 x 25.4 cm)
Museum of Fine Arts, Boston. Gift of Alfred Stieglitz (24.1727).
Not included in the exhibition.
Reproduction page 66.

Alfred Stieglitz: *Georgia O'Keeffe: A Portrait — Head*
Gelatin silver print, 7 1/2 x 9 1/8 in (19.1 x 23.2 cm)
National Gallery of Art, Washington, Alfred Stieglitz Collection
(1980.70.17). Photograph by Philip A. Charles.
Reproduction page 24.

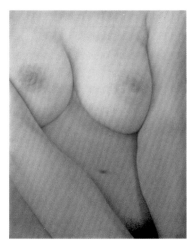

Alfred Stieglitz: *Georgia O'Keeffe: A Portrait — Breasts*
Gelatin silver print, 9 3/4 x 7 13/16 in (24.8 x 19.8 cm)
National Gallery of Art, Washington, Alfred Stieglitz Collection
(1980.70.109). Photograph by Dean Beasom.

Alfred Stieglitz: *Georgia O'Keeffe: A Portrait — Hands*
Gelatin silver print, 9 7/16 x 7 1/2 in (24 x 19.1 cm)
National Gallery of Art, Washington, Alfred Stieglitz Collection
(1980.70.119). Photograph by Dean Beasom.
Reproduction page 32, top.

Alfred Stieglitz: *Portrait of Georgia O'Keeffe*
Chloride print, 9 7/8 x 7 7/8 in (25.1 x 20 cm)
Photograph © 1992 The Art Institute of Chicago, Alfred Stieglitz
Collection (1949.761). All rights reserved.
Reproduction page 34.

Georgia O'Keeffe: *Music — Pink and Blue I*
Oil on canvas, 35 x 29 in (88.9 x 73.7 cm)
Collection of Barney A. Ebsworth. Photograph by Steven Sloman.
Reproduction page 35.

Georgia O'Keeffe: *Orange and Red Streak*
Oil on canvas, 27 x 23 in (68.6 x 58.4 cm)
Philadelphia Museum of Art, Alfred Stieglitz Collection. Bequest of
Georgia O'Keeffe. Photograph by Steven Sloman.
Reproduction page 36.

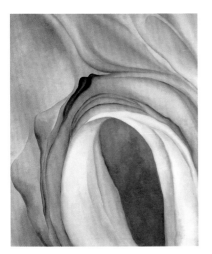

Georgia O'Keeffe: *Music — Pink and Blue II*
Oil on canvas, 35 x 29 1/8 in (88.9 x 74 cm)
Collection of Whitney Museum of American Art, New York. Gift of
Emily Fisher Landau in honor of Tom Armstrong (91.90).

1920

Alfred Stieglitz: *Rainbow, Lake George*
Gelatin silver print, 4 1/2 x 3 1/2 in (11.4 x 8.9 cm)
National Gallery of Art, Washington, Alfred Stieglitz Collection
(1949.3.456). Photograph by Philip A. Charles.
Reproduction page 37.

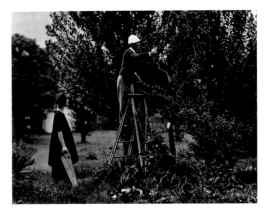

Alfred Stieglitz: *Georgia O'Keeffe: A Portrait*
Chloride print, 4 x 5 in (10.2 x 12.7 cm)
Museum of Fine Arts, Boston. Gift of Alfred Stieglitz (24.1736).

Alfred Stieglitz: *Rainbow, Lake George*, c. 1920
Gelatin silver print, 4 7/16 x 3 9/16 in (11.3 x 9 cm)
National Gallery of Art, Washington, Alfred Stieglitz Collection
(1949.3.457)
Not reproduced.

Alfred Stieglitz: *Lake George Barn*, c. 1920
Chloride print, 9 9/16 x 7 9/16 in (24.3 x 19.2 cm)
Photograph © 1992 The Art Institute of Chicago, Alfred Stieglitz
Collection (1949.779). All rights reserved.
Reproduction page 71.

Alfred Stieglitz: *Georgia O'Keeffe: A Portrait — Profile*
Gelatin silver print, 9 3/16 x 7 11/16 in (23.3 x 19.5 cm)
National Gallery of Art, Washington, Alfred Stieglitz Collection
(1980.70.135). Photograph by Philip A. Charles.
Reproduction page 92.

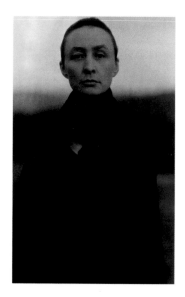

Alfred Stieglitz: *Georgia O'Keeffe: A Portrait*
Gelatin silver print, 8¼ x 5¼ in (21 x 13.3 cm)
National Gallery of Art, Washington, Alfred Stieglitz Collection
(1980.70.141). Photograph by Philip A. Charles.

Alfred Stieglitz: *Hands and Thimble — Georgia O'Keeffe*
Platinum print, 9¼ x 7¹¹⁄₁₆ in (23.5 x 19.5 cm)
Collection of The Museum of Modern Art, New York. Gift of David
H. McAlpin.
Reproduction page 94.

1921

Georgia O'Keeffe: *Lake George with Crows*
Oil on canvas, 28½ x 25 in (72.4 x 63.5 cm)
The Georgia O'Keeffe Foundation. Photograph © 1987 Malcolm
Varon, New York.
Reproduction page 42.

Georgia O'Keeffe: *Apple Family III*, c. 1921
Oil on canvas, 8 x 11 in (20.3 x 27.9 cm)
The Georgia O'Keeffe Foundation. Photograph © 1987 Malcolm
Varon, New York.
Reproduction page 63.

Georgia O'Keeffe: *Apple Family A*
Oil on canvas, 10 x 8 in (25.4 x 20.3 cm)
Collection of Mr. and Mrs. Gerald P. Peters, Santa Fe.
Reproduction page 64.

Alfred Stieglitz: *Georgia O'Keeffe: A Portrait*
Gelatin silver print, 3⅝ x 4⅝ in (9.2 x 11.7 cm)
National Gallery of Art, Washington, Alfred Stieglitz Collection
(1980.70.173). Photograph by Dean Beasom.
Reproduction page 65.

Alfred Stieglitz: *Georgia O'Keeffe: A Portrait — Neck*
Gelatin silver print, 9½ x 7½ in (24.1 x 19.1 cm)
Collection of Hanna and Manfred Heiting, Brussels.
Reproduction page 69.

Alfred Stieglitz: *Apple and Drops of Rain*
Chloride print, 5 x 4 in (12.7 x 10.2 cm)
Museum of Fine Arts, Boston. Gift of Alfred Stieglitz (24.1735).
Not reproduced.

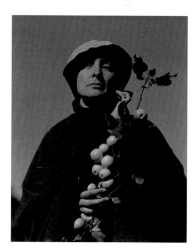

Alfred Stieglitz: *Georgia O'Keeffe: A Portrait — with Apple Branch*
Gelatin silver print, 4⁷⁄₁₆ x 3⁹⁄₁₆ in (11.3 x 9 cm)
National Gallery of Art, Washington, Alfred Stieglitz Collection
(1980.70.175). Photograph by Philip A. Charles.

1922

Georgia O'Keeffe: *Ends of Barns*
Oil on canvas, 16 x 22 in (40.6 x 55.9 cm)
Museum of Fine Arts, Boston. Gift of Mr. and Mrs. William H.
Lane, Juliana Cheney Edwards Collection, Emily L. Ainsley Fund,
and Grant Walker Fund.
Reproduction page 70.

Georgia O'Keeffe: *My Shanty, Lake George*
Oil on canvas, 20 x 27 in (50.8 x 68.6 cm)
© The Phillips Collection, Washington. Photograph by Edward
Owen.
Reproduction page 39.

Alfred Stieglitz: *Apples and Gable, Lake George*
Gelatin silver print, 4 ⅝ x 3 ⅝ in (11.7 x 9.2 cm)
Collection of The Museum of Modern Art, New York. Anonymous
Gift.

Alfred Stieglitz: *Dancing Trees*
Palladio print, 8 x 10 in (20.3 x 25.4 cm)
Museum of Fine Arts, Boston. Gift of Alfred Stieglitz (24.1734). Not
included in the exhibition.
Reproduction page 61.

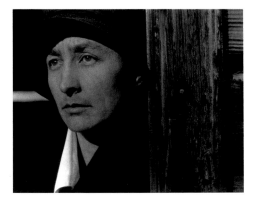

Alfred Stieglitz: *Georgia O'Keeffe*
Chloride print, 7 ⁷⁄₁₆ x 9 ½ in (18.9 x 24.2 cm)
Photograph © 1992 The Art Institute of Chicago, Alfred Stieglitz
Collection (1949.749). All rights reserved.

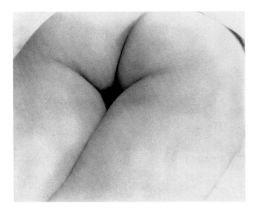

Alfred Stieglitz: *Georgia O'Keeffe: A Portrait*
Gelatin silver print, 7 ⁹⁄₁₆ x 9 ⁹⁄₁₆ in (19.2 x 24.3 cm)
National Gallery of Art, Washington, Alfred Stieglitz Collection
(1980.70.184). Photograph by Philip A. Charles.

Alfred Stieglitz: *Music — A Sequence of Ten Cloud Photographs, No. I*
Chloride print, 8 x 10 in (20.3 x 25.4 cm)
Museum of Fine Arts, Boston. Gift of Alfred Stieglitz (24.1732).
Not included in the exhibition.
Reproduction page 38.

Alfred Stieglitz: *Music — A Sequence of Ten Cloud Photographs, No. V*
Gelatin silver print, 9 ½ x 7 ⅝ in (24.1 x 19.4 cm)
National Gallery of Art, Washington, Alfred Stieglitz Collection (1949.3.833). Photograph by Philip A. Charles.
Reproduction page 46, right.

Alfred Stieglitz: *Apple and Drops of Rain*
Gelatin silver print, 4 ⅜ x 3 ⁷⁄₁₆ in (11.1 x 8.7 cm)
National Gallery of Art, Washington, Alfred Stieglitz Collection (1949.3.529). Photograph by Dean Beasom.
Reproduction page 62.

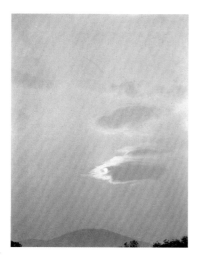

Alfred Stieglitz: *Music — A Sequence of Ten Cloud Photographs, No. VIII*
Gelatin silver print, 9 ⅜ x 7 ½ in (23.8 x 19.1 cm)
National Gallery of Art, Washington, Alfred Stieglitz Collection (1949.3.836). Photograph by Dean Beasom.

1923

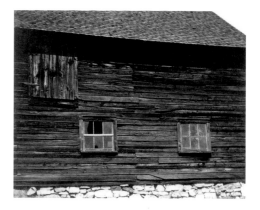

Alfred Stieglitz: *Barnside*
Gelatin silver print, 3 ⅝ x 4 ⅝ in (9.2 x 11.7 cm)
National Gallery of Art, Washington, Alfred Stieglitz Collection (1949.3.610). Photograph by Philip A. Charles.

Alfred Stieglitz: *Songs of the Sky — Portrait of Georgia No. 2*
Gelatin silver print, 3 ⅝ x 4 ⁹⁄₁₆ in (9.2 x 11.6 cm)
National Gallery of Art, Washington, Alfred Stieglitz Collection (1949.3.844). Photograph by Philip A. Charles.
Reproduction page 46, left.

Georgia O'Keeffe: *Spring*
Oil on canvas, 18 x 14 in (45.7 x 35.6 cm)
Collection of Gabriella Rosenbaum, Chicago. Photograph courtesy of The Art Institute of Chicago.
Reproduction page 72.

Georgia O'Keeffe: *Pattern of Leaves*, c. 1923
Oil on canvas, 22 ⅛ x 18 ⅛ in (56.2 x 46 cm)
© The Phillips Collection, Washington. Photograph by Edward Owen.
Reproduction page 68.

Georgia O'Keeffe: *Calla Lilies*
Oil on board, 32 x 12 in (81.3 x 30.5 cm)
Private Collection. Photograph by Steven Sloman.
Reproduction page 93.

Georgia O'Keeffe: *Grey Line with Black, Blue, and Yellow*, c. 1923
Oil on canvas, 48 x 30 in (121.9 x 76.2 cm)
The Museum of Fine Arts, Houston. Museum purchase with funds
provided by the Agnes Cullen Arnold Endowment Fund.
Photograph by Steven Sloman.
Reproduction page 98.

Alfred Stieglitz: *Spiritual America*
Gelatin silver print, 4 ½ x 3 ⅝ in (11.4 x 9.2 cm)
Private Collection.
Reproduction page 100.

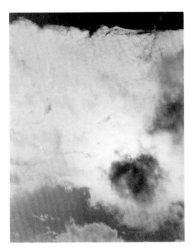

Alfred Stieglitz: *Songs of the Sky*
Gelatin silver print, 4 ⅝ x 3 ⅝ in (11.7 x 9.2 cm)
The Phillips Collection, Washington, Alfred Stieglitz Collection. Gift
of Georgia O'Keeffe, 1949 (159E). Photograph by Edward Owen.

1924

Alfred Stieglitz: *Mountains and Sky, Lake George*
Gelatin silver print, 9 ⅝ x 7 ½ in (24.4 x 19.1 cm)
Philadelphia Museum of Art. Gift of Carl Zigrosser (1975-26-1).
Reproduction page 44.

Alfred Stieglitz: *Songs of the Sky*
Gelatin silver print, 4 ⅝ x 3 ⅝ in (11.7 x 9.2 cm)
The Phillips Collection, Washington, Alfred Stieglitz Collection. Gift
of Georgia O'Keeffe, 1949 (155B). Photograph by Edward Owen.
Reproduction page 46, top.

Georgia O'Keeffe: *Dark Abstraction*
Oil on canvas, 24 ⅞ x 20 ⅞ in (63.2 x 53 cm)
The Saint Louis Art Museum, Missouri. Gift of Charles E. and Mary
Merrill (187:1955). Photograph by Steven Sloman.
Reproduction page 45.

Georgia O'Keeffe: *Petunia and Coleus*
Oil on canvas, 36 x 30 in (91.4 x 76.2 cm)
Collection of Mr. and Mrs. Gilbert H. Kinney. Photograph by Steven
Sloman.
Reproduction page 95.

Georgia O'Keeffe: *Red Canna*, c. 1924
Oil on canvas, mounted on masonite, 36 x 29 ⅞ in
(91.4 x 75.9 cm)
Collection of The University of Arizona Museum of Art, Tucson. Gift
of Oliver James.
Reproduction page 97.

1925

Georgia O'Keeffe: *White Birch*
Oil on canvas, 36 x 30 in (91.4 x 76.2 cm)
Private Collection. Photograph by Lee Stalsworth.
Reproduction page 60.

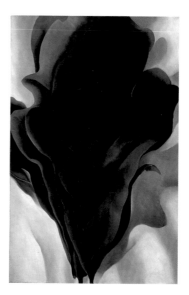

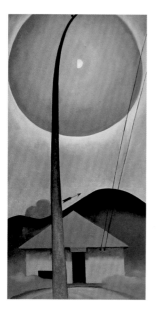

Georgia O'Keeffe: *Large Dark Red Leaves on White*
Oil on canvas, 32 x 21 in (81.3 x 53.3 cm)
© The Phillips Collection, Washington. Photograph by Edward
Owen.

Georgia O'Keeffe: *Little House with Flagpole*
Oil on canvas, 35½ x 17½ in (90.2 x 44.5 cm)
The Gerald Peters Gallery, Santa Fe.

Georgia O'Keeffe: *Black and Purple Petunias*
Oil on canvas, 20 x 25 in (50.8 x 63.5 cm)
Private Collection. Courtesy of The Gerald Peters Gallery, Santa Fe.
Photograph by Steven Sloman.
Reproduction page 67.

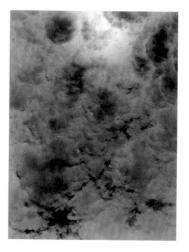

Alfred Stieglitz: *Equivalent*
Gelatin silver print, 4⅝ x 3⅝ in (11.7 x 9.2 cm)
The Phillips Collection, Washington, Alfred Stieglitz Collection. Gift
of Georgia O'Keeffe, 1949 (171E). Photograph by Edward Owen.

Alfred Stieglitz: *Equivalent*

Gelatin silver print, 4⅝ x 3⅝ in (11.7 x 9.2 cm)

The Phillips Collection, Washington, Alfred Stieglitz Collection. Gift of Georgia O'Keeffe, 1949 (220A). Photograph by Edward Owen. Reproduction page 99.

1926

Georgia O'Keeffe: *White Abstraction (Madison Avenue)*

Oil on canvas, 32½ x 12 in (82.6 x 30.5 cm)

Museum of Fine Arts, St. Petersburg, Florida. Gift of Charles and Margaret Stevenson Henderson in memory of Hunt Henderson. Photograph by Steven Sloman.

Reproduction page 101.

Georgia O'Keeffe: *The Shelton with Sunspots*

Oil on canvas, 48½ x 30¼ in (123.2 x 76.8 cm)

Photograph © 1992 The Art Institute of Chicago. Gift of Leigh B. Block (1985.206). All rights reserved.

Reproduction page 105.

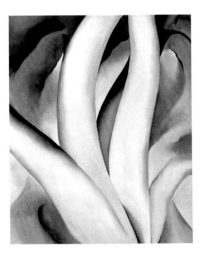

Georgia O'Keeffe: *Birch Trees at Dawn on Lake George*

Oil on canvas, 36 x 30 in (91.4 x 76.2 cm)

The Saint Louis Art Museum, Missouri. Gift of Mrs. Ernest W. Stix (14:1964).

Georgia O'Keeffe: *City Night*

Oil on canvas, 48 x 30 in (121.9 x 76.2 cm)

The Minneapolis Institute of Arts. Gift of the Regis Corporation, Mr. and Mrs. W. John Driscoll, the Beim Foundation, the Larsen Fund, and by public subscription.

Reproduction page 106.

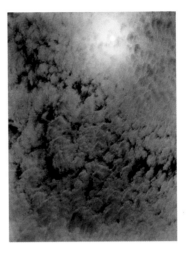

Alfred Stieglitz: *Equivalent*

Gelatin silver print, 4⅝ x 3⅝ in (11.7 x 9.2 cm)

The Phillips Collection, Washington, Alfred Stieglitz Collection. Gift of Georgia O'Keeffe, 1949 (177E). Photograph by Edward Owen.

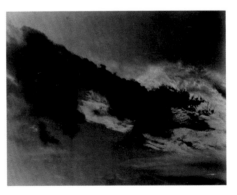

Alfred Stieglitz: *Equivalent*

Gelatin silver print, 4⅝ x 3⅝ in (11.7 x 9.2 cm)

The Phillips Collection, Washington, Alfred Stieglitz Collection. Gift of Georgia O'Keeffe, 1949 (228A). Photograph by Edward Owen.

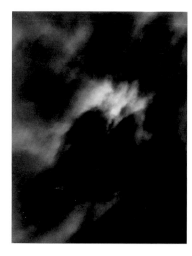

Alfred Stieglitz: *Equivalent*
Gelatin silver print, 4 ⅝ x 3 ⅝ in (11.7 x 9.2 cm)
The Phillips Collection, Washington, Alfred Stieglitz Collection. Gift
of Georgia O'Keeffe, 1949 (175A). Photograph by Edward Owen.

1927–1928

Georgia O'Keeffe: *East River from the Shelton*, 1927–28
Oil on canvas, 27 ¹⁄₁₆ x 21 ¹⁵⁄₁₆ in (68.7 x 55.7 cm)
New Jersey State Museum, Trenton. Purchased by Friends of the
Museum with a gift from Mary Lea Johnson (FA 1972.229).
Reproduction page 102.

Georgia O'Keeffe: *Red Hills, Lake George*, 1927
Oil on canvas, 27 x 32 in (68.6 x 81.3 cm)
© The Phillips Collection, Washington. Photograph by Edward
Owen.
Reproduction page 47.

Georgia O'Keeffe: *Iris [Dark Iris No. 1]*, 1927
Oil on canvas, 32 x 12 in (81.3 x 30.5 cm)
Taylor Museum for Southwestern Studies of the Colorado Springs
Fine Arts Center. Photograph by Steven Sloman.
Reproduction page 90.

Georgia O'Keeffe: *Dark Iris No. 2*, 1927
Oil on canvas, 32 x 21 in (81.3 x 53.3 cm)
Private Collection.
Reproduction page 77.

Alfred Stieglitz: *Georgia O'Keeffe: A Portrait — Prospect Mountain,
Lake George*, 1927
Gelatin silver print, 4 ⅝ x 3 ¹¹⁄₁₆ in (11.7 x 9.4 cm)
National Gallery of Art, Washington, Alfred Stieglitz Collection
(1980.70.223). Photograph by Philip A. Charles.
Reproduction page 91.

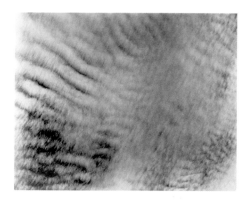

Alfred Stieglitz: *Equivalent*, 1927
Gelatin silver print, 4 ⅝ x 3 ⅝ in (11.7 x 9.2 cm)
The Phillips Collection, Washington, Alfred Stieglitz Collection. Gift
of Georgia O'Keeffe, 1949 (141D). Photograph by Edward Owen.

1929

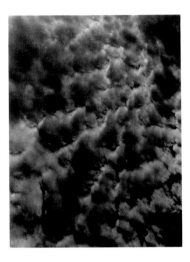

Alfred Stieglitz: *Equivalent*
Gelatin silver print, 4⅝ x 3⅝ in (11.7 x 9.2 cm)
The Phillips Collection, Washington, Alfred Stieglitz Collection. Gift
of Georgia O'Keeffe, 1949 (167A). Photograph by Edward Owen.

Alfred Stieglitz: *Equivalent, Set C, No. 5*
Gelatin silver print, 4⅝ x 3⅝ in (11.7 x 9.2 cm)
The Phillips Collection, Washington, Alfred Stieglitz Collection. Gift
of Georgia O'Keeffe, 1949 (216E). Photograph by Edward Owen.
Reproduction page 76.

Alfred Stieglitz: *Equivalent, Series 20, No. 9*
Gelatin silver print, 4⅝ x 3⅝ in (11.7 x 9.2 cm)
The Phillips Collection, Washington, Alfred Stieglitz Collection. Gift
of Georgia O'Keeffe, 1949 (226B). Photograph by Edward Owen.
Reproduction page 96.

Georgia O'Keeffe: *Lake George Window*
Oil on canvas, 40 x 30 in (101.6 x 76.2 cm)
Collection of The Museum of Modern Art, New York. Acquired
through the Richard D. Brixey Bequest, 1945.
Reproduction page 41.

1930

Georgia O'Keeffe: *Black and White*
Oil on canvas, 36 x 24 in (91.4 x 61 cm)
Collection of Whitney Museum of American Art, New York. Fiftieth
anniversary gift of Mr. and Mrs. R. Crosby Kemper (81.9).
Photograph by Steven Sloman.
Reproduction page 117.

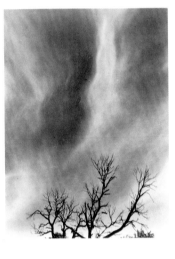

Alfred Stieglitz: *Equivalent*
Gelatin silver print, 4⅝ x 3⅝ in (11.7 x 9.2 cm)
The Phillips Collection, Washington, Alfred Stieglitz Collection. Gift
of Georgia O'Keeffe, 1949 (175B). Photograph by Edward Owen.

Alfred Stieglitz: *Little House, Lake George*
Gelatin silver print, 3½ x 4⁹⁄₁₆ in (8.9 x 11.6 cm)
Private Collection.
Reproduction page 73.

Alfred Stieglitz: *Georgia O'Keeffe: A Portrait*
Gelatin silver print, 9⅜ x 7⁵⁄₁₆ in (23.8 x 18.6 cm)
National Gallery of Art, Washington, Alfred Stieglitz Collection
(1980.70.252). Photograph by Dean Beasom.
Reproduction page 112.

Alfred Stieglitz: *Georgia O'Keeffe*
Chloride print, 8 x 9⅜ in (19.3 x 23.8 cm)
Reproduction page 114.

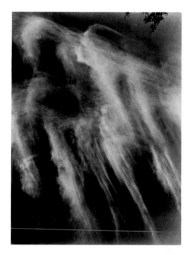

Alfred Stieglitz: *Equivalent*
Gelatin silver print, 4⅝ x 3⅝ in (11.7 x 9.2 cm)
The Phillips Collection, Washington, Alfred Stieglitz Collection. Gift
of Georgia O'Keeffe, 1949 (153B). Photograph by Edward Owen.

1931

Alfred Stieglitz: *Later Lake George*
Gelatin silver print, 7⁷⁄₁₆ x 9⁵⁄₁₆ in (18.9 x 23.7 cm)
Reproduction page 43.

Alfred Stieglitz: *Equivalent*
Gelatin silver print, 4⅝ x 3⅝ in (11.7 x 9.2 cm)
The Phillips Collection, Washington, Alfred Stieglitz Collection. Gift
of Georgia O'Keeffe, 1949 (149C). Photograph by Edward Owen.
Reproduction page 75.

Alfred Stieglitz: *From My Window at the Shelton — Southeast*
Gelatin silver print, 7⅜ x 9⅜ in (18.7 x 23.8 cm)
National Gallery of Art, Washington, Alfred Stieglitz Collection
(1949.3.1201). Photograph by Philip A. Charles.
Reproduction page 103.

Alfred Stieglitz: *Georgia O'Keeffe: A Portrait — with Cow Skull*
Gelatin silver print, 9⁵⁄₁₆ x 7⅜ in (23.7 x 18.7 cm)
National Gallery of Art, Washington, Alfred Stieglitz Collection
(1980.70.263). Photograph by Dean Beasom.
Reproduction page 110.

Alfred Stieglitz: *Georgia O'Keeffe: A Portrait — with Cow Skull*
Gelatin silver print, 9⁷⁄₁₆ x 7½ in (24 x 19.1 cm)
National Gallery of Art, Washington, Alfred Stieglitz Collection
(1980.70.262).
Not reproduced.

Georgia O'Keeffe: *Horse's Skull with White Rose*
Oil on canvas, 31 x 17 in (78.7 x 43.2 cm)
Private Collection. Photograph by Steven Sloman.
Reproduction page 115.

Georgia O'Keeffe: *Cow's Skull on Red*, 1931–36
Oil on canvas, 36 x 40 in (91.4 x 101.6 cm)
Museum of Western Art, Denver. Photograph by Steven Sloman.
Reproduction page 111.

1932

Georgia O'Keeffe: *Cow's Skull with Calico Roses*
Oil on canvas, 36¹⁵⁄₁₆ x 24 in (91.2 x 61 cm)
Reproduction page 113.

Alfred Stieglitz: *Later Lake George*, c. 1932
Gelatin silver print, 9½ x 7½ in (24.1 x 19.1 cm)
Photograph © 1992 The Art Institute of Chicago, Alfred Stieglitz
Collection (1949.773). All rights reserved.

Alfred Stieglitz: *Georgia O'Keeffe: A Portrait — In Automobile*,
1932–33
Gelatin silver print, 7⅜ x 9⅜ in (18.7 x 23.8 cm)
National Gallery of Art, Washington, Alfred Stieglitz Collection
(1980.70.285). Photograph by Philip A. Charles.
Reproduction page 108.

1933

Alfred Stieglitz: *From the Shelton, Looking West*
Gelatin silver print, 9½ x 7½ in (24.1 x 19.1 cm)
Collection of Edward Lenkin and Katherine Meier. Photograph by
Lee Stalsworth.
Reproduction page 107.

Alfred Stieglitz: *Georgia O'Keeffe*
Gelatin silver print, 9³⁄₁₆ x 7¹¹⁄₁₆ in (23.3 x 19.5 cm)
© The Cleveland Museum of Art. Gift of Cary Ross, Knoxville,
Tennessee (35.52).
Reproduction page 109.

Alfred Stieglitz: *Hand and Wheel*
Gelatin silver print, 9½ x 7½ in (24.1 x 19.1 cm)
© The Cleveland Museum of Art. Gift of Cary Ross, Knoxville,
Tennessee (35.99).
Reproduction page 116.

1934–1935

Alfred Stieglitz: *Later Lake George*, 1934
Chloride print, 9⁹⁄₁₆ x 7⁹⁄₁₆ in (24.3 x 19.2 cm)
Photograph © 1992 The Art Institute of Chicago, Alfred Stieglitz
Collection (1949.763). All rights reserved.
Reproduction page 40.

Alfred Stieglitz: *From the Shelton*, 1935
Chloride print, 9½ x 7⁹⁄₁₆ in (24.1 x 19.2 cm)
Photograph © 1992 The Art Institute of Chicago, Alfred Stieglitz
Collection (1949.786). All rights reserved.

ACKNOWLEDGMENTS

The Phillips Collection's exhibition, *Two Lives* started life as an investigation into the work and letters of Georgia O'Keeffe and Alfred Stieglitz. The themes and correspondences that ultimately became the basis of the show also served as touchstones for a collaborative book project with Callaway Editions in New York. Because Stieglitz's photographs and O'Keeffe's paintings are of such different sizes, it was clear from the beginning that juxtapositions ideally suited for a book—where dimensions can be changed at will—would not suit the requirements of an exhibition. For this reason the book, *Two Lives* can be thought of as the spiritual equivalent of the exhibition, although in reality it is also something self-contained. It is a pleasure to thank the book's co-editor, Thomas West, and his staff, for following so closely the goal of the exhibition, which was to present coherent sequences from the highly personal conversation that developed between two great American artists.

The success of this project depended of course upon the help and cooperation of many people and institutions. My sincere thanks go to The Georgia O'Keeffe Foundation for its guidance and support in making both the book and the exhibition a reality. I especially want to thank Elizabeth Glassman, President, and Juan Hamilton, Director, for their patience and cooperation with our many requests.

The Phillips Collection is also immensely grateful to our corporate sponsor, the IBM Corporation, whose early and strong financial support made the *Two Lives* exhibition possible.

Neither book nor exhibition could have come into being without the generosity and enthusiasm of lenders, and the thirty-four individuals and institutions who were willing to share their works are to be warmly thanked. I am especially grateful to J. Carter Brown, Director, and Sarah Greenough, Curator of Photography, at the National Gallery of Art who made substantial contributions from their collection of Stieglitz photographs.

Numerous libraries and archives were instrumental to the realization of this project. I am particularly grateful to Donald Gallup, Patricia C. Willis, Laurie Misoura, Steven Jones, and Scott MacPhail at the Beinecke Rare Book and Manuscript Library, Yale University for their assistance throughout the project. Our undertaking also builds upon the ground-breaking research of scholars whose publications on Stieglitz and O'Keeffe include Jack Cowart, Sarah Greenough, and Juan Hamilton, *Georgia O'Keeffe: Art and Letters* (Washington, D.C.: National Gallery of Art, 1987); Bram Dijkstra, "America and Georgia O'Keeffe," in *Georgia O'Keeffe: The New York Years* (New York: Callaway/Knopf, 1991); Charles C. Eldredge, *Georgia O'Keeffe* (New York: Abrams, 1991); Sarah Greenough and Juan Hamilton, Alfred *Stieglitz: Photographs and*

Writings (Washington, D.C.: National Gallery of Art, 1983); Sue Davidson Lowe, *Alfred Stieglitz: A Memoir/Biography* (New York: Farrar, Straus, Giroux, 1983); Barbara Buhler Lynes, *O'Keeffe, Stieglitz and the Critics, 1916–1929* (Ann Arbor, Michigan: UMI Research Press, 1989); Sarah Whitaker Peters, *Becoming O'Keeffe: The Early Years* (New York: Abbeville, 1991); and Roxana Robinson, *Georgia O'Keeffe* (New York: Harper & Row, 1989).

I am indebted to the guidance provided by fellow catalogue authors, Belinda Rathbone and Roger Shattuck. I especially want to thank Nicholas Callaway and Alexandra Arrowsmith of Callaway Editions, who initially encouraged us to explore a dual exhibition of Alfred Stieglitz and Georgia O'Keeffe. I also want to thank Merry Foresta for her careful reading of my manuscript. We owe a considerable debt to Jonathan Ritter, Carey Sherman, and Terri Southwick of Arnold & Porter for offering sound advice at crucial moments in the development and production of this book. A special word of thanks is also due to Bert Clarke.

It is a special pleasure to offer heartfelt thanks to the staff at The Phillips Collection who have brought their insight, enthusiasm, and hard work to this project. I am indebted to Elizabeth Chew, Assistant Curator, whose unfailing and effective assistance played a vital role in all aspects of the exhibition. Special contributions were also made by: Stephen B. Phillips, Executive Assistant to the Curatorial Department and Special Exhibitions and Tour Coordinator; Patricia Richmond, Intern; Karen Schneider, Librarian; Ignacio Moreno, Director of Visual Resources; Penny Saffer, Director of Development; Cathy Card Sterling, Director of Corporate Foundation Relations. Finally I must thank Eliza Rathbone, Chief Curator, and Laughlin Phillips, Director and Chairman of the Board of Trustees, for their unfailing support throughout this project.

Elizabeth Hutton Turner
Associate Curator
The Phillips Collection
Washington D.C.

Quotations from the plate sections:

page 3: Henry Tyrrell, from a review of Georgia O'Keeffe's first show at Stieglitz's 291 gallery; *Christian Science Monitor,* May 4, 1917.

page 23: Georgia O'Keeffe to Anita Pollitzer, October 1915; see Clive Giboire, ed., *Lovingly Georgia, The Complete Correspondence of Georgia O'Keeffe and Anita Pollitzer,* (New York: Simon & Schuster, 1990), p. 40. Alfred Stieglitz to Georgia O'Keeffe, June 1916; see Anita Pollitzer, *A Woman on Paper: Georgia O'Keeffe* (New York: Simon & Schuster, 1988), p. 140.

page 33: Alfred Stieglitz to Elizabeth Stieglitz Davidson, June 16, 1918; Yale Collection of American Literature, New Haven, Connecticut.

page 59: Georgia O'Keeffe to Elizabeth Stieglitz Davidson, October–November, 1920; Yale Collection of American Literature, New Haven, Connecticut.

page 89: Alfred Stieglitz to Rebecca Strand, May 17, 1929; see Roxana Robinson, *Georgia O'Keeffe* (New York: Harper and Row, 1989), p. 336. Georgia O'Keeffe to Blanche Matthias, April 1929; ibid, p. 319.

page 109: Georgia O'Keeffe, *Georgia O'Keeffe: A Portrait by Alfred Stieglitz* (New York: The Metropolitan Museum of Art, 1978), p. 17.

This book was produced by Callaway Editions, under the direction of Nicholas Callaway and Charles Melcher. Alexandra Arrowsmith and Thomas West edited the book and were assisted by Jin Park. Design was by Brian Wu and Jan Uretsky, assisted by Toshiya Masuda. Production was directed by True Sims, assisted by Ivan Wong. Sub-rights were coordinated by Kate Giel. Katherine Dacey, Martha Lazar, Monica Moran, and José Rodríguez assisted all of the above.

Susan Moldow was the editor for the book at HarperCollins, assisted by David Rakoff and Joseph Montebello, Creative Director of the HarperCollins Adult Trade Group. Meredith Ward, Barbara Bergeron, and Laura Burns copyedited and proofread the manuscript.

Type was composed with QuarkXPress software for Macintosh by Brian Wu and Jan Uretsky, using the Trade Gothic family of typefaces from Adobe Systems. Film negatives were produced by Typogram, New York.

The book was printed and bound by R.R. Donnelley & Sons Company in Willard, Ohio, under the supervision of Richard Benson and Nicholas Callaway. Jackie Barndollar and Jay Shutts represented R.R. Donnelley & Sons.

The images were produced by Richard Benson of Newport, Rhode Island, using the Agfa ColorScape system. He created the separations with the PIX color system, and output the film on an Agfa SelectSet 5000 imagesetter.

All of the pictures were scanned at 400 dots per inch resolution, and then converted to 200 line per inch halftones with the Agfa PIX system. The color paintings were reproduced using the custom ink tables that can be created in PIX. Scans of the original transparencies were tonally adjusted through the use of individually generated look-up tables. The black and white photographs were reproduced from gray scale scans, often modified in RGB colorspace, and each picture was printed in three colors using a dense black and two shades of gray. The tonal gradation for each of these colors was modified to suit each picture individually in order to match the weight and tonal depth of Stieglitz's prints.

The equipment used to create the images was donated by Agfa Division of Miles Inc., Wilmington, Massachusetts. Reproductions of such high quality could only be achieved by the sophisticated technology that Agfa possesses. Callaway appreciates the generosity of this organization for sharing its knowledge and assisting in many other ways. Jonathan Agger, Susan Brain, Peter Broderick, John Omvik, Eric Schwarzkopf, Lee Silverman, and Earl Stokes were instrumental in the success of this collaboration.